America's Mountain
The 10th Mountain I
(Light Infantry)

Samuel M. Katz

CONCORD
PUBLICATIONS COMPANY
CONCORD COLOR SERIES

We welcome authors who can help
expand our range of books. If you
would like to submit material, please
feel free to contact us.

We are always on the look-out for new,
unpublished photos for this series.
If you have photos or slides or
information you feel may be useful to
future volumes, please send them to us
for possible future publication.
Full photo credits will be given upon
publication.

ISBN 962-361-714-3
Printed in Hong Kong

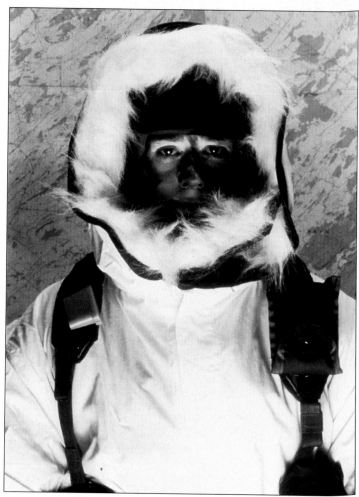

Front Cover

During one of the many sub-freezing afternoons at Front Drum, a division rifleman in protective winter gear awaits weapons inspection. That same rifleman an hour later, undergoes a snowbound combat obstacle course during exercises. Note fur lined hood covering Fritz-style Kevlar infantry ballistic protective helmet. (Courtesy: R.D. Murphy/10th Mountain Division.

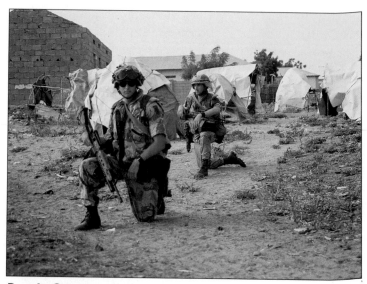

Back Cover

Classic portrait of the light troopers on patrol - a rifleman and the squad gunner, armed with a M249 SAW, cautiously move through a Somali village. (via Joel Paskauskas II)

FORT DRUM, NEW YORK, DECEMBER 1992: On a snow covered peak surrounded by pine trees and dusted with the white remnants of an upstate New York winter's storm, two soldiers, conveniently camouflaged by their white coveralls, patiently awaits the order to fire. The soldiers are an anti-tank team, expert sharpshooters with their M47 Dragon Medium Anti-Tank Guided Weapon, and have been laying in wait in the snow for nearly four hours. Their Dragon ATGW is lethal against armor, and the approaching tank's only hope in eliminating the threat is to locate the Dragon team, and obliterate it with a burst of fire from its 105mm main armament gun. But the Dragon team has an edge—they are invisible. These soldiers are experts in winter warfare, and can function freely in five feet of snow and in sub-freezing temperatures. As mountain troopers expected to operate in the winter, these men are also expert in utilizing the geographic and climatic conditions (snow, rain and ice) in their surroundings to their maximum advantage—they can turn a beautiful snowfall into a convenient and indistinguishable veil of camouflaging cover; they can live in the woods and survive in the elements without supply or outside assistance in the most frigid of temperatures; and, they can turn a storybook snow covered hill or forest into a lethal field of fire. Most importantly, they are expert in becoming invisible—a most valued combat skill when part of a unit trained to fight in small components. Although a two-man Dragon team is no answer to advancing armor, this team is meant to stalk, harass, and destroy; in high snows and narrow mountain ravines, two-man anti-tank teams can be as effective as a full division of armor, especially a team, trained to march dozens of kilometers in high snows with speed and stealth, and also armed with 84mm AT-4s slung across their backs. As the tank, a remote controlled armored mock-up, advances through the narrow mountain road, the order to fire is given. The trigger is depressed and the Dragon launched in a furious explosion; the gunner's white winter smock catches fire from the blast but it is extinguished by the cooling snow. In a trail of destruction, the warhead hits the vehicle and erupts in a powerful explosion. Yet even before the "tank" is completely devoured by flames, the tank-killer team has picked up its gear and slinked silently into the treeline toward their next ambush. This exercise is nothing special for them—after all, they are veterans of the 10th Mountain Division (Light Infantry). One of America's finest.

The division does not only operate in the snow.

BAIDOA, SOMALIA, DECEMBER 1992: On a sun-baked roadway in one of the cities hit hardest by the civil-war's induced starvation, a squad of men that are used to temperatures below 32° (F) find themselves sweltering in conditions where the heat reaches 100° (F)—in the shade! Laden down by a Kevlar flak vest, special load bearing vest, and the weight of web gear loaded to capacity with ammunition and survival supplies, the infantrymen struggle to keep their concentration centered on the road ahead of them, and on the Spartan foliage to either sides of them; their M16A2s, cocked and loaded with a 30-round magazine of 5.56mm ammunition grows heavier by the second. The desert pattern Battle Dress Uniforms (BDUs) each soldier is wearing is drenched in the soldier's perspiration, and a pool of sweat has settled under the lining of their Kevlar "Fritz" infantry ballistic helmets. A rifleman walks the point, followed closely by a M249 Squad Automatic Weapon (SAW) light machine gunner, ready at a mili-second's notice to lay down a blanket of 1,000 rounds per minute fire against the men of the warlords—armed with anything from AKMs ("AK-47s"), RPGs, to 12.7 mm (.50 caliber) Heavy Machine Guns, 20mm antiaircraft cannons and 106mm Recoilless Rifles armed on pick-up trucks called "technicals"—men eager to exact an American body count and interfere with the delivery of emergency supplies. As the patrol continues, the sergeant commanding the advancing detail

orders them to "look alive...and stay alert! "..."After all," the sergeant offers in a reinforcing tone, "you are soldiers of the 10th!"

These men trudging their gear in the sweltering hell of Africa are also soldiers of the 10th Mountain Division. Perhaps soldiers of the snow and cold are a bit out of their usual elements but not of their mandate as a U.S. Army Light Infantry Division (Light Infantry).

PORT-AU-PRINCE, HAITI, OCTOBER 1994: The brutal forces of repression were now a thing of the past. On the garbage-strewn streets of Haiti's capital, men wearing the "X" patch on their Woodlands patrolled neighborhoods once ruled by murderous thugs. Not a soldier in the unit knew what to expect, and fingers caressed M-16A2 triggers with tense strength—would the locals attack them with machetes and knives or would opponents of President Aristede openly engage the troopers with automatic weapons? America's mountain warriors were once again deployed in harm's way, once again securing the New World Order.

The new and modern 10th Mountain Division (Light Infantry) is a unique creation of the United States military, yet it is a combat formation with a rich and illustrious past. The first 10th Mountain Division was formed on July 15, 1943, as a combination special forces/specialized military formation; the original call, put out from the division's home in Camp Hale, Colorado, was for soldiers who were skilled in cross-country skiing and mountain-climbing. They were to be used in the treacherous W.W.II Italian campaign as a force of capable mountaineers that could infiltrate through German lines over mountainous terrain to unhinge the enemy's defenses for large-scale Allied offensive efforts. Although trained as skiers and mountaineers (the division's soldiers were seen roaming Italy with picks and rope), the force was soon to find out that full-scale combat does not distinguish between the mountaineering soldier and the "regular" infantrymen. The division fought the bitter campaigns of the Po Valley, and suffered heavy casualties. In the one year of operational service in Italy, the division suffered 4,072 dead and wounded. A heavy price to bear for such a young force in such a brief period of time. The 10th Mountain Division returned to the United States in 1946, and was, for all purposes, demobilized in 1948; its regiments and battalions spread out to various other infantry divisions in the U.S. Army's Order of Battle. The division's emblem, two crossed M1 Garand main battle rifle M5 bayonets making the roman numeral "10" ("X") became part of the war-time army's folklore of a fighting force of skilled soldiers who served their nation with honor and great sacrifice.

On December 4, 1984, however, the 10th Mountain Division was reborn. As part of the U.S. Army's Directive 185-1, the 10th, along with several other formations were re-classified as LIGHT infantry units; the 10th adopting its old name of "10th Mountain Division (Light Infantry)". Other light infantry units: 6th Light Infantry Division (Fort Richardson. Alaska), 7th Light Infantry Division (Fort Ord, California), 25th Light Infantry Division "Tropic Lightnings" (Schofield Barracks, Hawaii), National Guard 27th Infantry Brigade (Syracuse, New York) and 29th Light Infantry Division, which has the 116th Infantry, "Stonewall Jackson Brigade" of Civil War and Omaha Beach D-Day fame (Fort Belvoir, Virginia). Recently the 7th LID was reduced and merged with elements of the 199th Infantry Brigade (Motorized) into the 2d Armored Cavalry Regiment based in Fort Lewis, Washington. The 2d ACR is slated to move to Fort Polk, Louisiana along with the 4/17th Air Cavalry (OH-58D Kiowa Warrior scout/attack helicopters) to act as a Joint Readiness Training Center (JRTC) Opposing Forces (OPFOR) aggressor and rapid contingency force asset to the designs and deployments of the XVIII Airborne Corps.

The serving U.S. Army Chief of Staff at that time, General Edward C. Meyer's objective behind the creation of these "light" forces was to facilitate the fast, easy, and virtually self-sufficient deployment of combat units to the world's hot spot using a minimum of airlift sorties. Just 463 C-141B Starlifter sorties can deliver an entire light infantry division compared to the well over 2,000 sorties needed to deliver a regular Army or Marine infantry division. The Germans in W.W.II came to the same conclusion by creating the 22d Luftlande Division to rapidly reinforce paratroopers with forces configured for air-landing, which along with their mountain troops proved decisive during the battle for Crete. A U.S. Light Infantry Division can cross the globe at high subsonic speed (600 mph) in a USAF transport jet and arrive in hours, ready for battle. With the advent of the new C-17 Globemaster III to replace the C-141B, short-take-off and landing (STOL) assault zone operations from dirt/grass areas, unused roads etc. as short as 3,000 feet long will be possible. The C-17B has double the capacity of a C-141B which could reduce the sorties needed to deliver a Light Infantry Division in half if centerline back-to-back seating kits are ordered. C-130 Hercules aircraft are available in large numbers now for STOL air-landing operations, though not as fast or with the cargo/troop capacity of a C-17.

It is one thing to bring these units into battle—it is the abilities of the men—and women—on the ground to do the job! The division's missions are: Combat Proficiency and Training In a Wide Variety of Settings (especially winter and mountainous regions); Antitank Role in Rough Terrain; Heliborne Assaults; Infantry Warfare; Rear-Area Security and Perimeter Defense; and, Urban and Built-Up Warfare (in both defensive and offensive roles)—these are responsibilities that the approximately 14,000 men of the 10th Mountain Division (Light Infantry) are perfectly capable in carrying out. Much of the division's training is conducted at their home base of Fort Drum, New York (formerly Camp Drum), near scenic Watertown close to the Canadian border, although the division conducts training operations at the U.S. Army's Jungle Warfare Training Center in Panama, as well as in Europe as part of various NATO exercises, especially the annual Reforger maneuvers. Many of the unit's NCOs and officer are also Ranger-qualified and Ranger-tabbed, having undergone the grueling Ranger course; a good number of the division's personnel go on to eventually serve in one of the U.S. Army Special Operations Command's Special Forces Groups (Airborne), the famous and legendary "Green Berets"; the 75th Ranger Regiment (Airborne), and the 160th Special Operations Aviation Regiment. The division's Order of Battle includes the 3rd, 14th, 22nd, and 87th Infantry Regiments); the 25th Helicopter Transport Regiment and the 17th Attack and Reconnaissance Helicopter Regiment (these include 110 UH-60 Blackhawk, Bell-212, AH-1S Cobra and OH-58 Kiowa helicopters; the 7th Field Artillery Regiment, and the 62nd Air Defense Artillery Battalion. All of the division's soldiers are proficiently trained infantrymen who are highly skilled with their personal weapons, as well as operating in small squads, brigade size task forces. Like most other elements of the U.S. military, the soldiers—men and women—of the division undergo the rudimentary basic training to become proficient soldiers, but these fighters are specialized. Their mandate is "mountain warfare," and, more correctly, winter warfare. From the picturesque surroundings near Fort Drum, 10th Mountain soldiers receive intensive instruction in the art of cold-weather survival, poor weather assaults, and the art of infiltrating enemy lines in both high-altitudes and bone-chilling cold. To successfully carry out their mandate, the 10th Mountain Division (Light Infantry) is also one of the most capable formations in the art of camouflage—from the soldier taught to blend into the surrounding hillside, to the air defense gunner taught to hide their Stinger and Vulcan positions so that they are invisible from both the air and the ground. The division conducts regular training exercise with the 1st, 2nd, and 3rd Ranger battalions, as well as Canadian paratroopers and special forces (from the 1st SSF), and annual training stints with the elite German Army's Fernspähkompanie (Long-Range Scout Company) and mountain troops from the 23rd Gebirgsjägerbrigade—the men who wear the infamous Edelweiss mountain flower badge.

The 10th Mountain Division is also one of the most lavishly equipped in the U.S. Army's Order of Battle, as its personnel are equipped with the most modern and high-tech (even low-tech) items of equipment—these range from extensive supplies of night scopes and night-vision devices, to innovative load bearing vests—Individual Tactical Load Bearing Vest (ITLBV) highly specialized web gear (also known by its acronym title of Individual Integrated Fighting System Tactical Load Bearing Vest), with side chest ammunition pouches, issued to the mountain troopers and US Special Forces, such as the Green Berets, and 75th Ranger Battalion. A truly self-sufficient division and a highly specialized force with own support forces (such as an MP company), the 10th Division also possesses a truly unique "elite" and "secretive" special forces unit within its order of battle—the 110th Military Intelligence Battalion's long-range reconnaissance unit, known by its acronym name of LRSU for Long Range Surveillance Unit. A combat reconnaissance force designed to gather intelligence on enemy movements, the LRSU's function is similar to that of the Army LRRPs during the Vietnam War; they, too, operate in small six-man reconnaissance teams. The 110th LRSU is among the finest combat units in the ENTIRE U.S. military—including the Special Forces, the Rangers, Marine Corps Force Recon, and even other "black" (covert) units.

Light infantry units are trained for virtually immediate mobilization, and equipped with palletized material that could be supplied quickly by air; they possess their own artillery, anti-tank, and attack/transport helicopter components chosen carefully for their rapid deployability. Another aspect of the light divisions and regiments was their flexibility to have elements—from other units—added onto their order of battles during immediate crisis deployments throughout the world. Although at the time of their reentry into the Army's Order of Battle, potential deployments of the light divisions appeared, on paper, at least, as preventative measures for despatch to hot spots contested by the superpowers in the Cold War—troubled lands in Central America, the Middle East and Asia. But the eventual collapse of communism triggered new realities—new potential battlefields in a "new world order" where rapid response by light forces agile in restricted terrain would be crucial to deterring war and preserving peace. Somalia was a perfect example of this overseas mission. During "Restore Hope" and UNOSOM II, the 10th Mountain Division contingent performed exceptionally well. Stationed near Baidoa, alongside Canadian airborne units, securing food supply routes and hunting down armed stragglers from the various militias and private armies of Somalia's internal fratricide.

As a testament to the division's new, unique and elevated status and role within the U.S. Army's Order of Battle, the 10th Mountain Division (Light Infantry) has now recently been placed under the command of the Army's XVIII Airborne Corps. The 10th Mountain Division (Light Infantry) is the only force in the American military truly prepared to fight a sustained mountain war—be it a limited conflict, to a full-scale conflagration. Although not much has been heard of this force, it is a unit that, in the coming years, promises to be as busy as any fighting formation in the world. Already a main component of "Operation Restore Hope," future conflicts in this world might soon be the operational domain of the American mountain troopers—from the crumbling chaos of the former Yugoslavia, to Kurdistan and Korea. In fact, when and if the United States deploys forces to Bosnia, it is likely that it will be the 10th Mountain Division in the vanguard of this most dangerous and

precarious assignment—in fact, winter-time counter-insurgency training has been ordered to units not currently deployed to Somalia. Only time will tell where the division's next deployment will be—Bosnia, the Golan Heights, the DMZ in Korea.

On September 9, 1994, news reports were leaked from Watertown New York that 2,000 10th Mountain Division personnel were preparing to head out toward Puerto Rico and commence training with U.S. Marines for possible—and inevitable—deployment to Haiti to be in the vanguard of the coordinated United Nations effort to restore democracy, or whatever semblance of democratic rule that had previously existed, to that troubled Caribbean island nation. The sweltering squalor of Port-au-Prince is a world away from the snow covered peaks of upstate New York and even the desert wasteland of Somalia. Haiti will prove to be a dangerous and precarious undertaking, but for the 10th Mountain Division, perhaps the most unheralded elite unit in the entire U.S. military, it is just a notch on their operational resume as duty calls. Few in Watertown, New York, wanted to believe that the Caribbean would be their next destination, but many knew it was only a matter of time.

The rumor mill was always busy at Fort Drum, and popular watering holes in rustic Watertown New York were always alive with news of possible deployment for "the division," but in early September 1994 it was busier than it had ever been. After Somalia, after the division's job well done in the famine vanquished hell of Somalia, there was first talk of deployment to Bosnia, as part of a multi-national peace-keeping force in and around Sarajevo, and then a rumor that the division would be deployed atop the Golan Heights as a buffer between Israel and Syria should a peace deal be worked out. Nobody in Fort Drum thought that the next time the division would be sent overseas into harm's way, that it would be in the Western Hemisphere, in the Caribbean, so close to home. No one ever uttered the word "Haiti." It wasn't a place anyone wanted to go.

In early September 1994, General David C. Meade, the division CO, received word from Washington that winter training for the division might have to be put on hold—at least for some of the units. He was told to ready hot weather supplies and the division's BDUs. An American military operation, either an invasion or peace-keeping occupation, was destined for Haiti. Meade, searching for maps of the Caribbean nation and Creole-speaking soldiers in his command, arranged to send a preliminary force of 2,000 light troopers to Puerto Rico to join U.S. Marines in jungle warfare training. If--and when--Haiti was to be invaded by an American-led coalition to restore ousted President Jeane-Bertrand Aristede to power and remove the rule of the Haitian generals, led by Lieutenant-General Raoul Cédras, 10th would be in the thick of things. President Clinton, without a national mandate, was determinded to use might against the poorest nation in the hemisphere regardless. The mission was known as "Operation Uphold Democracy".

It was decided that should the U.S. invade, the Marines would storm the beaches and the 10th would be heli-lifted inland to secure key roads, towns and installations. During the occupation, the light troopers would act as peace-keepers and policemen. In Watertown, troops boarded transports that would fly them to Norfolk, Virginia, home to Atlantic Command-the command in charge of any operation - where they boarded the aircraft carrier U.S.S. Dwight D. Eisenhower for the quick sail for the Haitian coast. Until the last moment, division officers were still "up in the air" as to what it was they were supposed to do once in Haiti-restore democracy, unarm a hostile force. What would the rules of engagement be?

What was known, however, that they would be deployed to Haiti in a novel example of the U.S. military's era of inter-service cooperation - a policy known in the vernacular as "adaptive joint force packaging." In the old days, Haiti would have been a job for the Marines. But, following the last minute agreement reached by the crisis negotiation team led by former President Jimmy Carter and strongman General Cédras, when U.S. troops were to land in Haiti with the cooperation of the Haitian military, the first wave ashore was the men-and woman- of the 10th courtesy of the UH-60 and Cobra gunships of the 1st Brigade. They had used the three-hundred meter long flight deck of the U.S.S. Dwight D. Eisenhower as a giant helicopter launching pad. In the morning of September 19, 1994, to a nation-wide audience watching the proceedings live on network TV, the choppers of the 1st Brigade landed at Port-60s, enough to block the sweltering Caribbean sun, buzzed the horizon en route toward their landing zone. The first to leap from the muffled beating of the UH-60 rotors were the men of the 2/22, the triple deuces, who, laden down with bulging rucksacks filled to capacity with ammo, grenades, assumed the position on the tarmac with weapons aimed and safeties down. The light troopers came to the party loaded heavy-carrying everthing they could, including their personal weapons, AT-4s and LAWs, night vision goggles and communications gear, and enough supplies to equip an entire Corps. Some 2/22 personnel carried rucksacks loaded with C-4 plastic explosives and detonating wires, other wore black bullet-proof vest underneath their Woodland pattern PASGTs. Many had added Maglight flashlights to the ends of the M16A2 5.56mm assault rifles.

Perhaps a sign that the mission will be carried out without bloodshed was best illustrated on the morning of September 20, 1994, General Meade met with his senior commanders at Port-au-Prince airport. Colonel Marcial Romulus, the Haitian Army's Chief of Operations, attended the gathering eager to cooperate. But on the docks of Port-au-Prince, under the eyes of 10th Division personnel, Haitian police mercilessly beat a crowd of Aristede supporters who had come to the dock to cheer on the Americans, while the 10th Division soldiers—under strict orders—did not intervene.

Perhaps this deployment will, in the end, be nothing more than a 1990s version of gunboat diplomacy. Perhaps, too, it will be a great test to the light troopers and their new role in the U.S. military's light troopers in the unpredictable and madcap scheme of things of the post-Cold War World.

The author would like to thank R.D. Murphy at 10th Mountain Division (Light Infantry) Public Affairs for the incredible support and generous assistance with this project, as well as the Public Affairs office at Force Command, and USAPAO in New York City. The publisher would like to thank the INTERNATIONAL TACTICAL STUDIES GROUP (ITSG) RR4 BOX 292C, RAEFORD, NC 28376, a non-profit think-tank/action group decicated to free world military equipment/tactical excellence:

Mlke Sparks, ITSG Director
Eric Graves, equipment design/analyst
Barrett tuttle, computer technician
Jeff Johnson, field equipment
Thomas Rowe, agency liaison
Ernest Hoppe, mobility/medical concepts
Brent Orr, military/ police actions
Miss Angela McConnel, bio-medical factors
Garvey Jonassaint, field medicine

REVIEWED FOR TECHNICAL ACCURACY BY THE INTERNATIONAL
Miss Lenora Cain, International communications
David Tran, physical fitness
Dan Godbee, Light Bicycle Infantry R & D
Miss Paula Herring, Intelligence
T. Mark Graham, technical research
MSG Michael Menzie , SF (retired)
MSG Lee Cashwell, SF (retired)

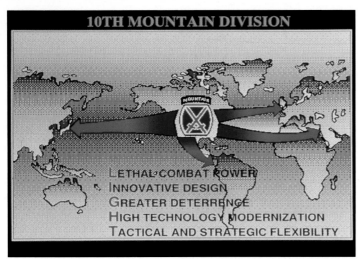

10TH MOUNTAIN DIVISION

LETHAL COMBAT POWER
INNOVATIVE DESIGN
GREATER DETERRENCE
HIGH TECHNOLOGY MODERNIZATION
TACTICAL AND STRATEGIC FLEXIBILITY

The Divisional lineage, motto, and display of past battlefields: Its reclassification as a Light Infantry Division in 1984 meant to allow its quick and fast deployment to the world's trouble spots. "Light" meant it deployed with the minimum of heavy equipment, which, for a force of mountain soldiers, this usually means combat deployment with whatever equipment was carried on one's back. (Courtesy: R.D. Murphy/10th Mountain Division)

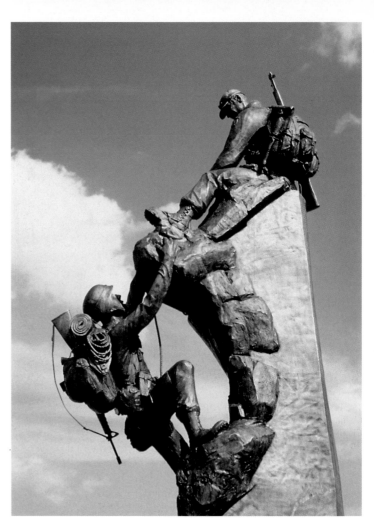

The 10th Mountain Division statue, "strategically positioned" at the entrance to the home base in Fort Drum, New York (near the Canadian border)—the challenges, sacrifices and victories of the division's campaigns in Italy during the Second World War. Among the division's most famous veterans is former Presidential candidate, now Republican Senator Robert Dole who was severely wounded and highly decorated for valor during fighting in W.W.II Italy. (Courtesy: R.D. Murphy/10th Mountain Division)

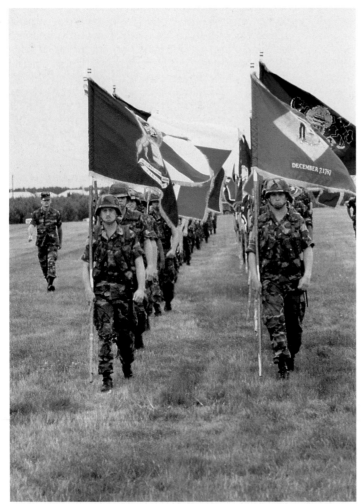

Parading for full inspection, before their regimental commanders, division soldiers perfect synchronized stepping on a grassy parade ground at Fort Drum. Note individual Tactical Load Bearing Vest (TLBV) highly specialized web gear (also known by its acronym title of Individual Integrated Fighting System or IFFS Tactical Load Bearing Vest), with side chest ammunition pouches, issued to the mountain troopers and U.S. Special Forces, such as the "Green Berets", and 75th Ranger Regiment. Product-improved versions will have mesh construction for better cooling, repositioned magazine pouches for low-crawling and built-in infiltration/exfiltration and rappel/mountaineering capabilities. (Courtesy: R.D. Murphy/10th Mountain Division)

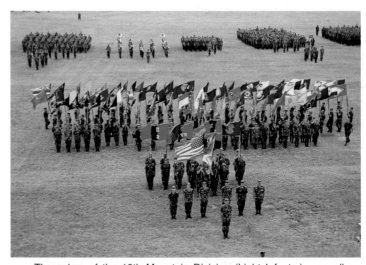

The colors of the 10th Mountain Division (Light Infantry), as well as portions of the illustrious past, present, and future, are presented during 4th of July MountainFest activities. The battle streamers indicate honors from W.W.II and soon to include Somalia. (U.S. ARMY)

Early Year Deployments

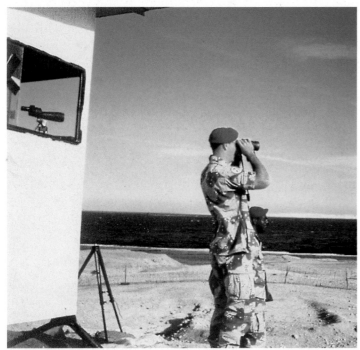

One of the division's first overseas deployments following its rebirth in 1984 was duty in the demilitarized Sinai, where it served as observers in the Multinational Force Observer (MFO) zone separating Egypt and Israel. Pictured here, a two man patrol scan the Straits of Tiran for any Camp David Accord violations. (Courtesy: R.D. Murphy/10th Mountain Division)

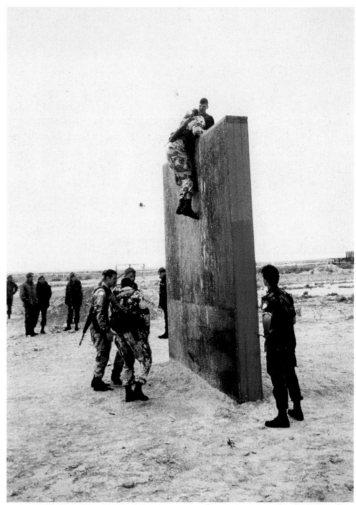

Making the most of their desert surroundings, the units despatched to Sinai to monitor the peace found the occasion and circumstance the perfect opportunity for some obstacle course combat training . All troopers wear 6-color desert pattern BDUs or commonly referred to as Desert Pattern Uniforms or "DPUs". Recent information is that both 6-color and 3-color DPUs will be retained in Army stockpiles to better adapt to different desert regions, though a reversible BDU ensemble for all climates is under development for lighter soldier's load, unit deployment weight and supply simplification/cost reduction. (Courtesy: R.D. Murphy/10th Mountain Division)

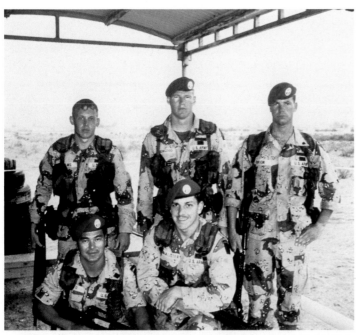

Posing for a group photo, 10th Mountain Division troopers display their newly issued desert pattern BDUs, and their "unique" combat utilities. The maroon beret was issued to all XVIII Airborne Corps MFO personnel serving in Sinai. Today, MFO personnel wear a reddish-brown beret so non-Airborne personnel can wear a distinctive headgear. There has been some discussion to authorizing the 10th Mountain Division soldiers to wear a dark brown beret to signify their elite status as America's "Mountain soldiers." (Courtesy: R.D. Murphy/10th Mountain Division)

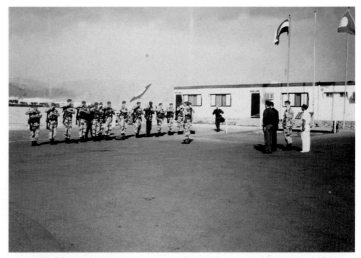

10th Mountain troopers present their colors to visiting United Nations and Egyptian military personnel at their home base in central Sinai. U.S. forces train each year with Egyptian troops during Operation Bright Star exercises. (Courtesy: R.D. Murphy/10th Mountain Division)

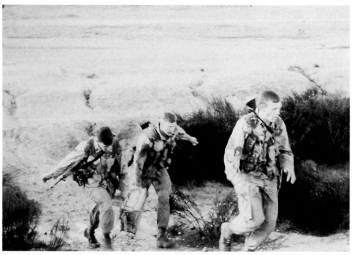

During defensive exercises in Sinai, 10th Mountain troopers race toward defensive pits to re-supply their comrades with ammunition. Although the Division's mission in Sinai was uneventful, the threat of terrorist attack remained an ever-present danger throughout their tour of duty in the Sinai Desert. Light infantry units can be very useful in desert warfare to hold key terrain at a fraction of the logistical support requirements of a mechanized force, but require transportation augmentation in the form of trucks and/or helicopters. Hanebrink has developed an Extreme Terrain Bike (ETB) with 10 -inch wide tires that offers another mobility solution for air-deployed light infantry units by providing a stealth mobility means over soft sand and snow. The U.S. Army is exploring these mobility tools for future operational use. (Courtesy: R.D. Murphy/10th Mountain Division)

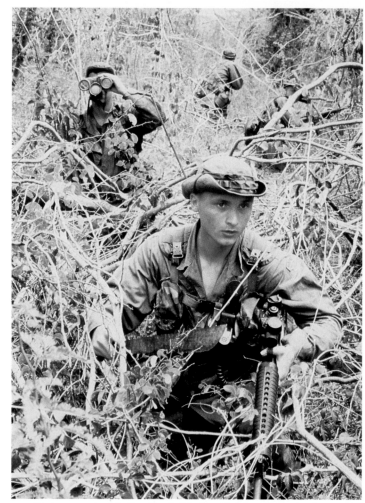

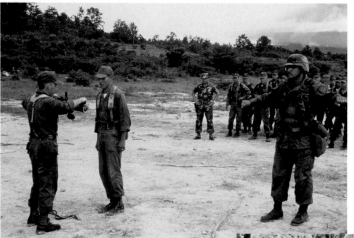

During exercises in the Jungle Warfare Training Center in Panama, a 3rd Battalion, 14th Infantry Regiment, sniper, 10th Mountain Division, negotiates 'a path through the thick underbrush. He wears olive drab fatigues, sweat-soaked "Boonie hat",. and an M16A2 5.56mm assault rifle equipped with 4X scope; note spotter, with his ubiquitous binoculars, in hand. (Courtesy: R.D. Murphy/10th Mountain Division)

Because of their expertise with small arms and infantry held anti-tank rockets/missiles, 10th Mountain personnel have been despatched throughout the hemisphere as advisors. Here, a 10th Division weapons specialist teaches a platoon of Honduran infantrymen the "art" of preparing an M72A2 Light Antitank-assault Weapon (LAW) 66mm rocket for firing. Unlike the long and heavy M136 AT4 rocket, the M72A2 launcher telescopes for easy carry by shorter stature soldiers slung across the back or strapped to the top of rucksacks. (Courtesy: R.D. Murphy/10th Mountain Division)

As the sniper team progresses through the jungle, their backup, all carefully clutching their M16A2s, follow in protective cover. Often, a sniper team will tag along as part of an infantry unit, then stay-behind to set up their hide site. From a distance, it would appear that only a patrol has moved through the area. (Courtesy: R.D. Murphy/10th Mountain Division)

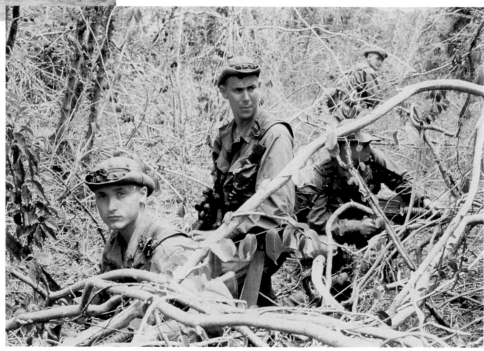

Looking more like an Aussie trooper in New Caledonia than a man trained to wage a full-scale war on skis, a 10th Mountain trooper cautiously patrols a stretch of jungle during maneuvers in Panama. Note telephone-like radio handset from field radio wrapped in plastic to protect it from the uncontrollable moisture and precipitation. The rifleman is armed with the M16A2. (Courtesy: R.D. Murphy/10th Mountain Division)

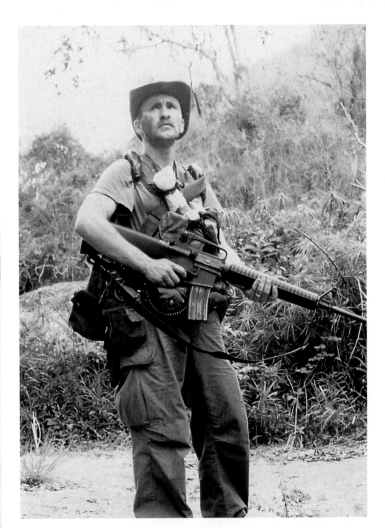

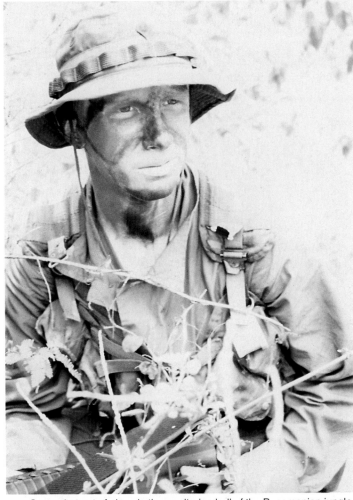

Somewhat out of place in the sweltering hell of the Panamanian jungle, a 10th Mountain rifleman, pauses after taking a quick break to replenish fluids. A drink-on-the-move system using a tube would allow hydration without stopping. Although their obvious mandate is mountain and winter warfare, Pentagon planners also comprehend that the world's hot spots—with their violent ability for flare-ups—are not geographically limited to the Swiss Alps or Canadian Rockies! (Courtesy: R.D. Murphy/10th Mountain Division)

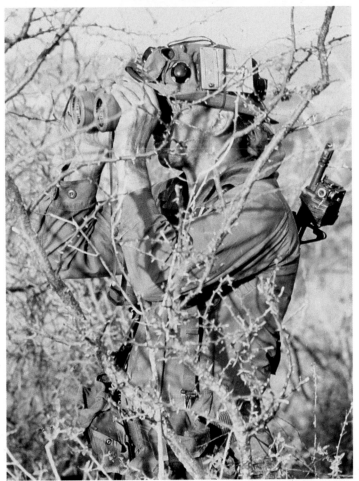

Perfectly camouflaged by olive drab and the natural surroundings, a 10th Mountain Division platoon leader gazes an open stretch of grass before ordering his men across during jungle maneuvers. Note MILES (Multiple Integrated Laser Engagement System) training system attached to the officer's body—once hit by the laser beam of an enemy's gun, the device chimes a pronounced beep indicating the hit individual is a "combat casualty!" (Courtesy: R.D. Murphy/10th Mountain Division)

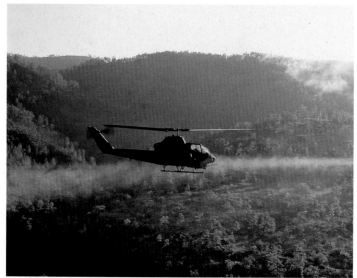

Zambrano, Honduras. A Bell helicopter AH-1S HueyCobra from the 1st Battalion, 17th Air Cavalry Regiment (10th Mountain Division), fires two 2.75-inch Hydra-70 rockets over the Honduran artillery range at Campo Del Balomple during training exercises meant to deter Nicaraguan forces from crossing the frontier. The Hydra-70 warheads are interchangeable to include high explosive, multi-purpose submunitions, smoke-screen and training rounds. They are carried in pods of 7 or 19. (U.S. ARMY)

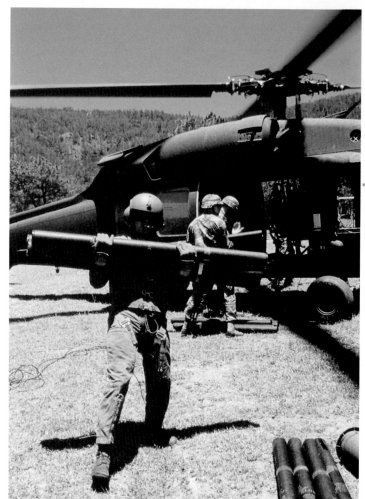

Mobile Forward Arming and Refueling Point (FARP): 17th Air Cavalry Regiment (10th Mountain Division) troopers carry 2.75-inch rockets from a UH-60 Blackhawk for loading onto an AH-1S Cobra helicopter prior to a combat run on the Campo Del Balomple range in support of 10th Mountain infantrymen holding on to a defensive perimeter during large-scale maneuvers close to the Nicaraguan border. The Cobra is being upgraded with C-NITE forward-looking infrared sensors to fly low-level at night and fire optically-tracked TOW IIB ATGMs through smoke, dust and fog. (U.S. ARMY)

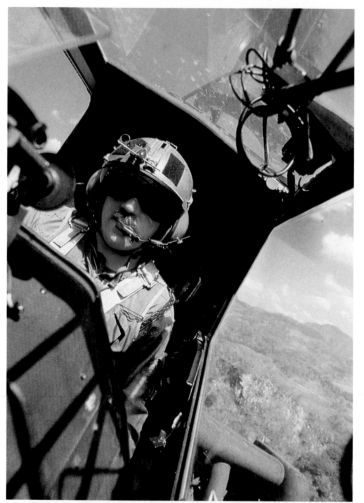

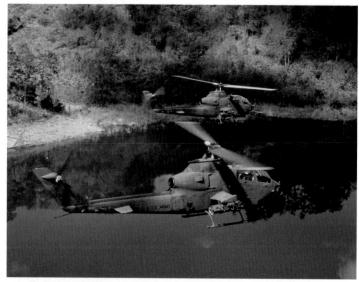

A Chief Warrant Officer 4 from the 1st Battalion, 17th Air Cavalry Regiment, pilots his AH-1S Cobra gunship toward the Nicaraguan border during exercises with the 10th Mountain Division. The U.S. Army is the only American service egalitarian enough to let Warrant Officers fly aircraft. By not worrying about competing for promotion in the commissioned officer ranks, these pilots can concentrate on combat flying skills; the reward has been the world's finest airmen and the best helicopter tactical "edge." Although a LIGHT infantry division, the 10th cannot function or survive without assistance from its aerial elements. (U.S. ARMY)

Two AH-1S Cobra helicopter gunships from the 17th Air Cavalry Regiment in flight for a combat run on the Camp Del Balomple range. President Ronald Reagan mobilized the U.S. exercise task force Dragon/Golden Pheasant, consisting of the 82nd Airborne Division and the 7th Light Infantry Division, as well, of course, the aerial and ground elements of the 10th Mountain Division, to discourage Nicaraguan forces from entering Honduras. (U.S. ARMY)

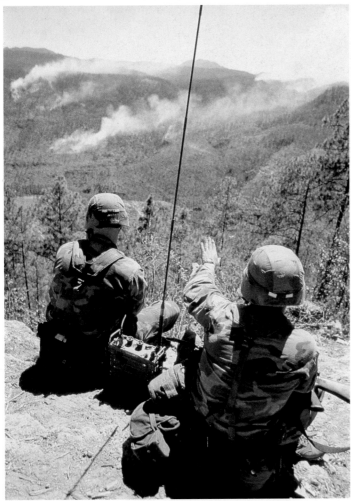

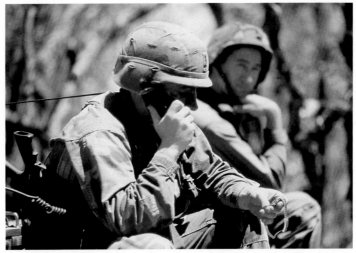

Captain David Holland, a fire support officer for the 1st Battalion, 17th Air Cavalry Regiment, "calls in the cavalry," in this case AH-1S attack choppers during the Dragon/Golden Pheasant exercises. He is synchronizing a TOW ATGM strike, while ordering infantry elements to attack. A drawback to TOW is that it must be tracked by the front seat gunner's cross-hairs to the target; exposing the Cobra to enemy fire. In Grenada, Marine Cobras were shot down trying to fire TOWs at Cuban recoilless rifle positions. The newer Hellfire ATGM is laser-guided and usually "fire and forget". (U.S. ARMY)

Members of the fire support team from the 17th Air Cavalry Regiment score the hits fired by an AH-1S Cobra over the Honduran artillery range at Campo Del Balomple during Operation Dragon/Golden Pheasant. Note woodland green pattern BDUs and PASGT (Personal Armor System Ground Troops) Kevlar "Fritz" infantry ballistic helmet worn. The "Fritz" helmet has saved many soldier's lives in combat in Grenada and Panama; even stopping AKM 7.62mm X 39mm assault rifle rounds. (U.S. ARMY)

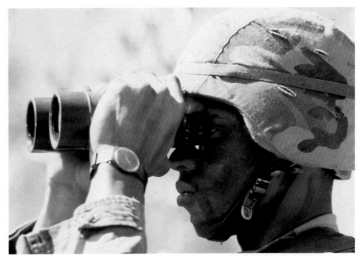

A member of the fire support team from the 17th Air Cavalry Regiment (10th Mountain Division) uses 7 x 50 Steiner binoculars to score the hits fired by an AH-1S Cobra helicopter over the Honduran artillery range at Campo Del Balomple during Operation Dragon/Golden Pheasant. The binoculars have a vertical and horizontal mile-scale for radioing corrected artillery/close air support ordnance delivery. (U.S. ARMY)

While division troopers on the ground simulate defending a fortified position under heavy enemy fire, an AH-1S Cobra helicopter from the 17th Air Cavalry Regiment takes off in the field for a combat run on the Camp Del Balomple range as an OH-58C Kiowa helicopter starts up its engines to "fly" reconnaissance and ECM shotgun! The new "D" model Kiowa Warrior has a mast-mounted infrared sight and laser designator for below the treetop observations, and an awesome armament package to include Hellfire ATGMs, 2.75" Hydra-70 rocket pods, .50 caliber Heavy Machine Gun packs, seats for 6 troops, folding rotor blades/tail fin and kneeling landing gear for transport 3 at a time in C-130 Hercules aircraft for STOL operations into 2,800 foot assault zones. The new C-17 has STOL capabilities for 7 Kiowa Warriors and can refuel the mini-gunships with JP-8 from its own tanks on the ground. (U.S. ARMY)

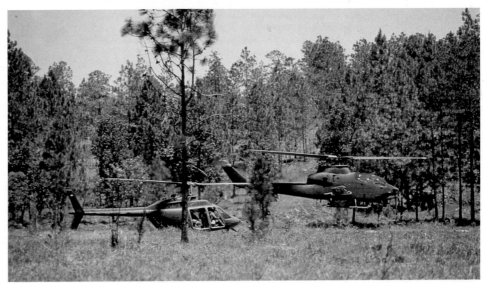

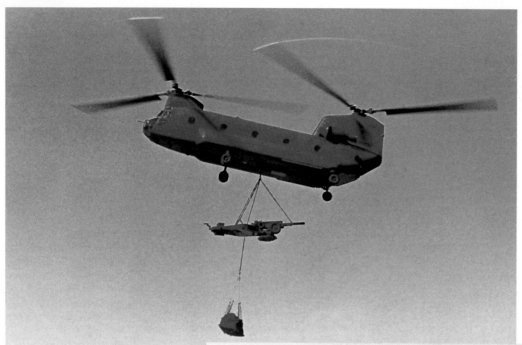

A CH-47D Chinook helicopter from the 25th Combat Aviation Regiment (10th Mountain Division) transport battalion sling-loads a M102 105mm howitzer during a training exercise. Ammunition is slung under the howitzer's trail legs; the gun crew sits inside the helicopter fuselage. Upon landing, the entire gun can be brought into action in under a minute. With a range of just 14 km, U.S. light units are outgunned by modern infantries with 35 km range 155mm Howitzers like the South African G-5/6 engineered by Canadian artillery genius, Dr. Gerald Bull. This can be rectified by new lightweight 155mm howitzers that are helicopter transportable by smaller Blackhawk helicopters. (U.S. ARMY)

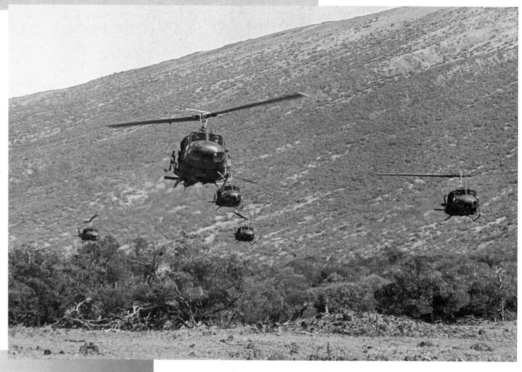

Pohakuloa Training Area, Hawaii. A UH-1H Iroquois (official, seldom used name) helicopters from the 25th Combat Aviation Regiment (10th Mountain Division) during air mobile assault training. Until phased out by the UH-60, the dependable Huey was the division's primary means of aerial transportation. In high, hot weather, the Huey lacks the power to lift a full infantry squad. (U.S. ARMY)

A 10th Mountain trooper from the 2nd Battalion, 3rd Infantry Regiment, armed with a FIM-92 Stinger Surface-to-Air Missile (SAM), takes aim at a drone flying overhead. The Stinger was used by the Afghanistan resistance to deny the Soviet Air Force low-level air superiority, a first in military history. Stinger is cold-launched to a safe altitude before the rocket motor ignites, reducing any backblast signature and allowing enclosed-area firings. Such infantry held air-defense weapons have truly made the division capable of being deployed, with minimal air support and air defense, to virtually any location in the world. (U.S. ARMY)

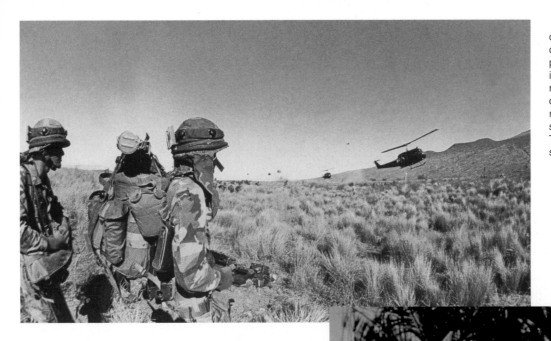

Equipped with the MILES system, division infantrymen observe as a flight of UH-1H Iroquois helicopters land and pick up the rifleman and grenadier team inserted behind "enemy" lines during maneuvers. Note the one quart canteen clipped to the side of the ALICE rucksack and compacted M72A2 LAW strapped under the rucksack top flap. The LAW can be jumped in without a special container this way. (U.S. ARMY)

Royal Australian Air Force Base at Darwin, Australia. A member of the 1st Battalion, 62nd Air Defense Artillery, shoulders a Stinger missile launcher, as his partner peers through a pair of field binoculars during Pitch Black '88, a joint Australia-U.S. exercise emphasizing night flying. Note that 62nd Air Defense Artillery members do not wear the division's crossed bayonet emblem, even though they are under the division's direct command and control. (U.S. ARMY)

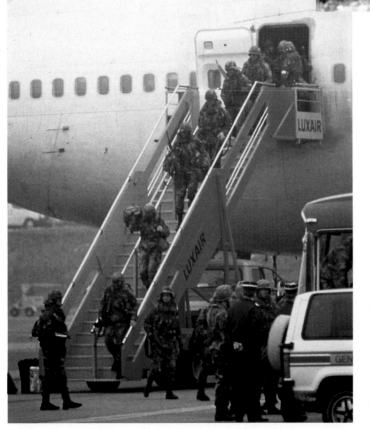

Luxembourg International Airport. Soldiers from the 1st Battalion, 22nd Infantry Regiment, 10th Mountain Division debark from a 747 aircraft en route to West Germany during exercise Reforger '90 in Germany. Commercial air (COMAIR) or Civilian Reserve Air Fleet (CRAF) aircraft can be used to move personnel across the ocean to free USAF transports to airlift vehicles/equipment. The soldiers all wear their BDU camouflage utilities, and "Fritz" infantry ballistic helmets. (U.S. ARMY)

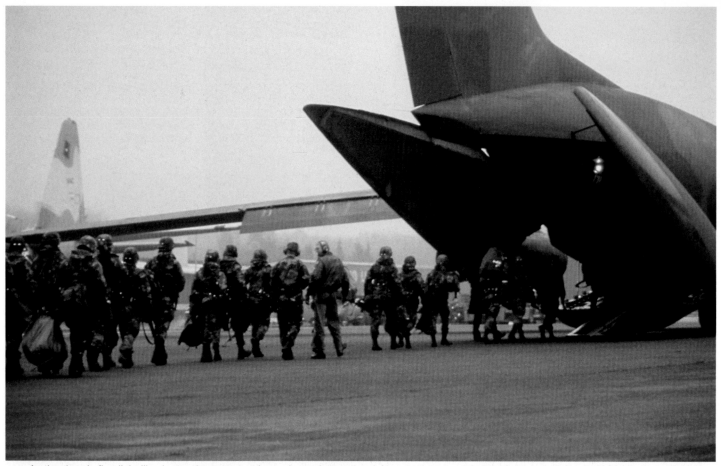

As the dawn's first light illuminates the tarmac at Luxembourg International Airport, the mountain light fighters from the 10th Division's 1st Battalion, 22nd Infantry, struggle with their laden down equipment while a USAF loadmaster guides them to the belly of an awaiting C-141B Starlifter. (U.S. ARMY)

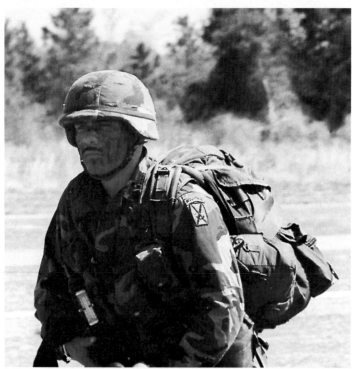

A soldier from the 10th Mountain Division (Light Infantry) patrols a perimeter at a "fortified perimeter" during NATO exercises. Photograph offers an excellent view of the divisional subdued patch of crossed bayonets, indicating the Roman numeral for 10, with the word "MOUNTAIN" lined overhead. He's wearing a large ALICE rucksack with frame. (U.S. ARMY)

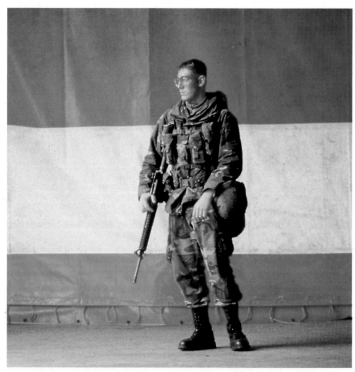

Antwerp, Belgium. Pfc. Ronald Neis, Co. A, 3rd Battalion, 14th Infantry, 10th Mountain Division waits to board a 435th Tactical Airlift Wing C-130E Hercules aircraft which will transport him to West Germany during exercise Reforger '90 (REturn of FORces to GERmany).The division played an integral role in the large-scale NATO exercises that preceded the collapse of the Soviet Union; the exercises allowed the 10th to conduct maneuvers with other European mountain units, including the Gebirgs division units in Germany. Note his ITLBV and ECWCS Gore-Tex parka. (U.S. ARMY)

Cold Weather High Altitude Warfare

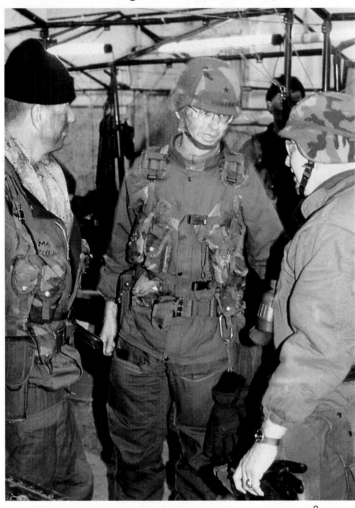

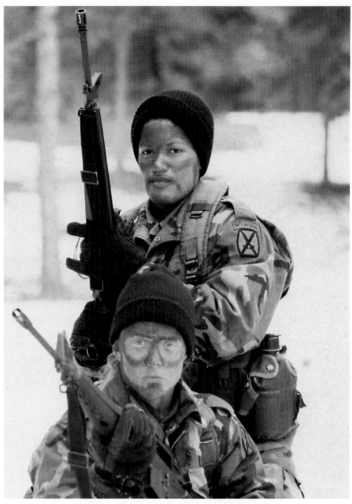

The division's vital command, control, and communications (C^3) center is visited by Brigadier-General Howard during large-scale exercises. All officers present wear two-piece olive-drab winter Chemical Protective Over-Garments (CPOGs), as well as individual Tactical Load Bearing Vests. Division commander Major-General Boylan, Jr., (left) wears black wool cap and desert pattern BDU scarf. (Courtesy: R.D.Murphy/10th Mountain Division)

Daunting portrait of two 10th Mountain Division riflemen—faces camouflaged to blend easily into the woodlands, wearing black woolen watch caps, and woodland pattern BDUs, and M16A1 Assault Rifles in hand. Current face paint comes in metal tubes but will be in a mirrored compact when tube supply runs out. Mirror in new compact needs a sight hole to be pop-out mirror for signaling/close air support marking. (Courtesy: R.D. Murphy/10th Mountain Division)

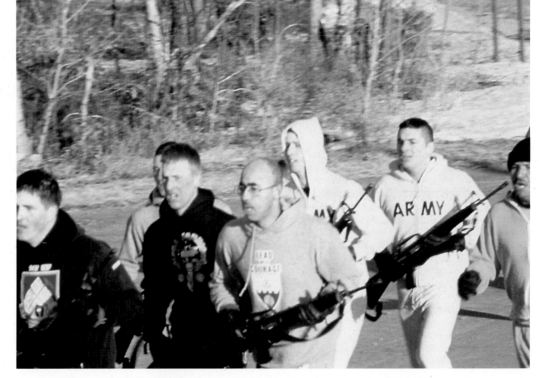

No matter what the unit, no matter where the deployment—from peace time to war—there will always be PT (physical training). Under the hypnotic beat of the sergeant's cadence, 10th Division troopers get their very early morning taste of PT on a frigid Fort Drum morning. The trooper, right, is wearing the division's 22nd Infantry Regiment's colors on his gray sweatshirt, while his comrades (left) wears the colors of the 87th Infantry Brigade on his black sweatshirt. (Courtesy: R.D. Murphy/10th Mountain Division)

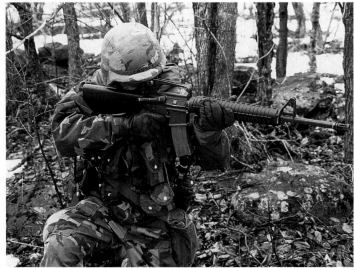

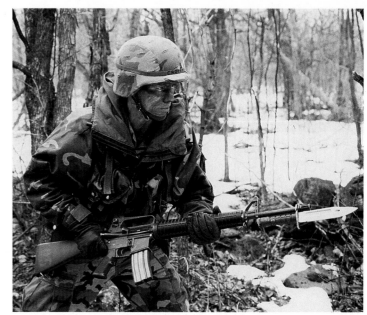

In perfect firing position, a 10th Mountain rifleman kneels on one knee, places his target on the tip of his sight, and then releases a three-round burst of 5.56mm fire from his M16A2 assault rifle. A 3-round burst is more likely to hit a target than uncontrolled automatic fire which studies show is aimed well above eye level beyond the third shot. He is wearing a ECWCS - Extended Cold Weather Clothing System Gore-Tex parka which gives lightweight wind/waterproof protection (1.8 pounds) but must be laundered with powder detergents and "steamed" with a close, but not touching iron to re-energize its water repellency occasionally. (Courtesy: R.D. Murphy/10th Mountain Division)

Wearing his woodland BDU pattern ECWCS Gore-Tex parka, 10th Mountain Division individual Tactical Load Bearing Vest, and an M16A2 extended with an wire-cutter M-9 bayonet, a 10th Division trooper obeys his order of "Charge!" The bayonet has still been useful in recent combat to psychologically unhinge enemies and to give killing power if ammunition runs out during the assault. Unlike folding stock weapons, the 44 inch long, solid stock, heavy barrel M16A2 makes for an excellent close-combat weapon with the bayonet attached. The A2 model's added strength improves its close-combat capability over the A1 model. (Courtesy: R.D. Murphy/10th Mountain Division)

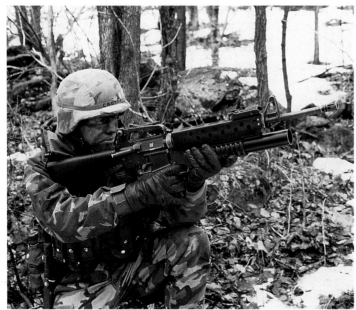

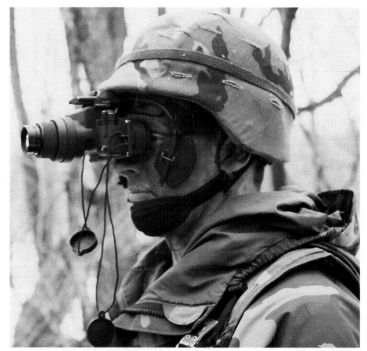

A 10th Mountain trooper, equipped with the M16/M203 40mm grenade launching system prepares to launch a 40mm grenade into a fortified pillbox using the accurate quadrant sights. An aging workhorse, the M203 is still a more than capable grenade launching system used throughout the American military, as well as in countless foreign armies, though bullet-launch rifle grenades could be issued to EVERY soldier to give them projected grenade capability as well as offer increased explosives effects over the palm-sized M203 40mm round without the 4 pound added weight of a M203 grenade launcher attached underneath the M16A2 assault rifle. A designated grenadier may not be in position to launch his grenade, if every squad member had rifle grenades, the target could be engaged without having to move into a line-of-sight firing position which would expose soldiers to enemy fire as the Navy SEALs learned in Panama. The photograph shows to advantage the load bearing vest worn by U.S. Army grenadiers. (Courtesy: R.D. Murphy/10th Mountain Division)

The 10th Mountain Division is an all-weather, as well as a "round-the-clock" combat formation. A 10th Division trooper models his third-generation image intensifier AN/PVS-7A night vision goggle with special head-mounted assembly. Night Vision Goggles (NVGs) like the PVS-7A and the improved "B" model cost several thousand dollars each and can take ambient light (star/moonlight or infrared flares) and amplifies it to make the night appear as "daytime". Third World Countries are buying NVGs en mass in light of U.S. combat successes in Panama and Desert Storm; we can no longer assume we are the only forces that can move at will during the night. The head harness can be worn with the NVG itself detached by a quick-release clip until needed. A new outer helmet holding system in use by Army Rangers is available from Litton of Tempe, Arizona so NVGs can be attached to the outside of PASGT Kevlar helmets like aviators do with their NVGs/helmets; eliminating the uncomfortable, extraneous head harness. (Courtesy: R.D. Murphy/10th Mountain Division)

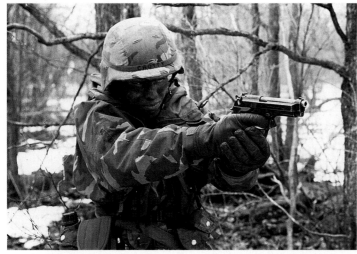

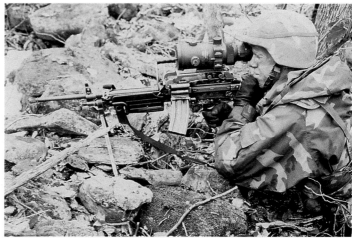

A 10th Mountain NCO prepares to empty a full clip of fifteen 9mm rounds from his Model 92-SBF Beretta (M9) automatic. Although the standard Colt .45 was a traditional weapon that had served the U.S. military for nearly eighty years, the 92SBF's accuracy and effectiveness has not been lost to its new owners. A white 3-dot low-visibility sighting system is provided though add-on self-luminous tritium sights would be more effective. A coil spring 18-round magazine is available for the M9. (Courtesy: R.D. Murphy/10th Mountain Division)

Stoic portrait of a 10th Mountain M249 light machine gunner. Note 5.56mm 30-round magazine inserted from the left side, and weapon equipped with an AN/PVS-4 "star-light" image intensifier scope. The M249 is a Belgian "Mini-mi" now used throughout the world and U.S. forces. Under the barrel is a gas control to allow more gas into the operation system for a higher rate of fire or to burn out carbon collecting in the gas tube. A quick-change barrel removed by a fixed handle offset to the side. The gunner also wears a "Fritz" Kevlar helmet with elastic camouflage band over his helmet cover. The band holds vegetation by tension around the helmet and has 2 strips of luminous tape "cat-eye" at the rear for night station keeping. The soldier's last name is usually printed in black ink block letters on the elastic band front in U.S. Army units. The band can ride up and fall off the helmet if the soldier doesn't secure the band with 550 cord. (Courtesy: R.D. Murphy/10th Mountain Division

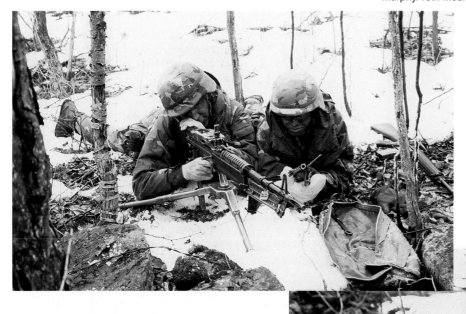

As the remainder of the squad proceeds down a ridge believed to be enemy (22nd Infantry Regiment) "ambush country", a 14th Infantry Regiment M60E1 medium machine gun team prepares to lay down a wall of covering fire. Although being replaced by the M249 LMG, the M60 MMG still remains a highly-capable platoon support weapon; especially when used in conjunction with the 15 pound M122 tripod and T/E. The M122 needs a small carry bag to be developed since its now carried in the open on the shoulder, exposed to the elements and tying up the hands holding it there. (Courtesy: R.D. Murphy/10th Mountain Division)

A division M60E1 gunner places a "target" into the center of his AN/PVS-4 image intensifier weapons sight and gazes across a stretch of an impromptu firing range. A lens cover has pinholes for daylight verification of the image intensifier's working condition and for battlesight zero. Although being gradually replaced in the squad unit level by the M249 SAW Light Machine Gun, the M60 Medium Machine Gun still remains a reliable and highly effective general support machine gun; especially when using the M122 tripod and traverse and elevating mechanism depicted above, for stable, dialed-in fire accuracy. (Courtesy: R.D. Murphy/10th Mountain Division)

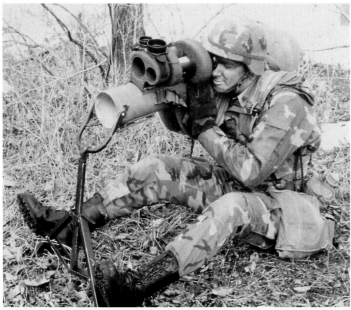

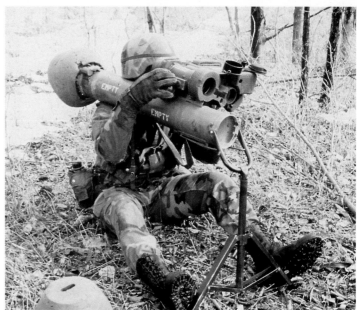

Although not the front line infantry-held anti-tank weapon it once was, especially with the proliferation of the LAW, "AT-4", "Carl Gustav" and the SMAW, the M47 Dragon medium anti-tank weapon (MAW) remains an effective defense against advancing armor. It can be an effective offensive weapon; the optically guided warhead is capable of penetrating 3 feet of reinforced concrete. There are twenty-four M47 Dragons attached to each division anti-tank company. There are two launcher/tracker systems; the reasonable weight day tracker and a 23 pound night infrared thermal tracker that is best transported by the company's HMMWV supply vehicle and used for unit observation/security and defensive DRAGON firings. The gunner wears the insulated and Gore-Tex lined Intermediate Cold Wet waterproof boot. (Courtesy: R.D. Murphy/10th Mountain Division)

A mountain trooper demonstrates the proper pose needed to successfully fire a M47 Dragon Medium Anti-Tank Guided Missile. Not commonly known is that a M175 firing adapter allows the Dragon to be fired with greater accuracy using the M122 machine gun tripod. (Courtesy: R.D. Murphy/10th Mountain Division)

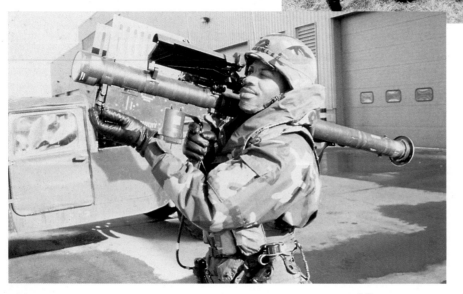

A three-man crew of the heavier 81mm M252 mortar set up their weapon under the watchful eyes of an instructor. The M252 is a British-designed weapon in widespread service in the United States military. A unique feature of the M252 is that its firing pin can be removed for removing mortar rounds stuck in the tube. (Courtesy: R.D. Murphy/10th Mountain Division)

A weapons instructor from the 62nd Air Defense Battalion demonstrates proper firing position, stance and poise in firing the STINGER hand-held SAM. The target is first optically tracked by the gunner, when the infrared sensor "locks on" the Mach 3 missile is fired. (Courtesy: R.D. Murphy/10th Mountain Division)

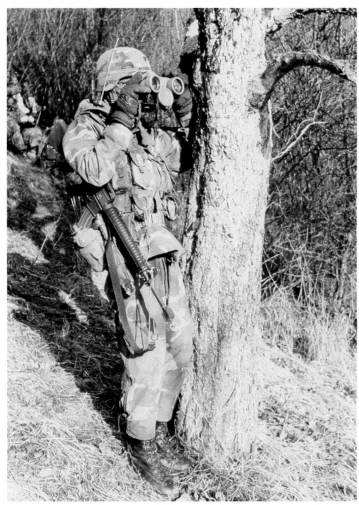

Taking cover behind a tree, a 10th Mountain trooper scans the valley below with a 7 x 50 M22 Steiner binocular for signs of enemy movement (soldiers from a different battalion, no less!) during exercises. The photograph shows off the individual Tactical Load Bearing Vest which can hold 6 30-round M16 magazines and 2 baseball-type M67 fragmentation grenades to advantage. A combination bullet-through rifle/hand grenade that could be thrown as a baseball or "stick" grenade as well as be launched from the M16 rifle muzzle would give every soldier in the squad a grenadier capability beyond hand range (40-300 meters) with a larger, more effective warhead than the M203 GL 40mm round. This would be tactically beneficial and simplify the myriad of ordnance/equipment U.S. soldiers carry into the field. (Courtesy: R.D. Murphy/10th Mountain Division)

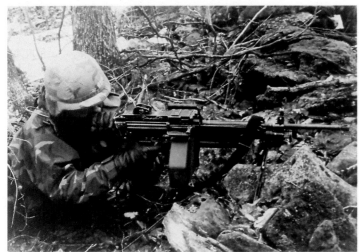

With D3A/B black leather gloves protecting his trigger fingers from the sub-freezing chill, a SAW light machine gunner prepares to unload a full box of 200 rounds of 5.56mm fire into the centers of several stationary targets. Its not commonly known, but the spare barrel must be fitted and zeroed for use with the M249; the front sight blade can be adjusted to match bullet strike with iron sight aimpoint. (Courtesy: R.D. Murphy/10th Mountain Division)

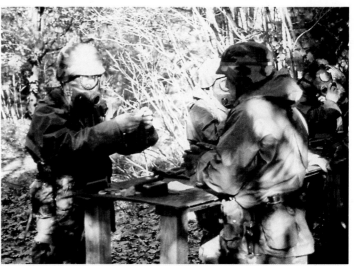

Having received their briefing and NBC warfare refresher course, 10th Mountain personnel prepare to enter the gas chamber for some realistic NBC warfare training. CS "tear gas" pellets are burned to create a cost-effective and very dense smoke for soldiers inside. Mountain soldiers enter, remove their masks or break the mask-to-face seal and must then re-clear their mask of tainted air using their held breath and masking procedures. This must be done within 9 seconds or as soon as possible to reduce the severe irritation caused by the CS agent. Soldiers move surprisingly fast in the gas chamber! (Courtesy:R.D. Murphy/10th Mountain Division)

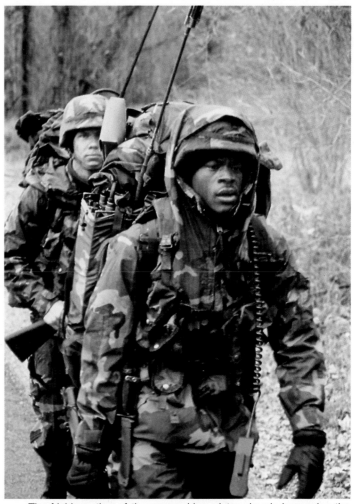

The frigid weather of the approaching winter already hampering the movements of the troopers in the field, troopers from the 87th Infantry Brigade close ranks as they prepare for the excruciating final leg of their journey. The soldiers are acclimatized to winter conditions after extended months of service. Note camouflage Field Pack Large Internal Frame (FPLIF) covering up the AN/PRC-77 FM field radio. The ECWCS Gore-Tex parka hood can be worn over the PASGT Kevlar helmet without significant vision loss. (Courtesy: R.D. Murphy/10th Mountain Division)

A soldier from a mortar company presents an imposing barrier during maneuvers at Fort Drum—he carries the M16A2 5.56mm assault rifle. Note Cold Weather fire-resistant (Nomex) face mask, and M-9 wire cutter bayonet at the ready. The face mask is part of the ECWCS system. The high visibility vest is for road guard duty during peacetime speed marches. (Courtesy: R.D. Murphy/10th Mountain Division)

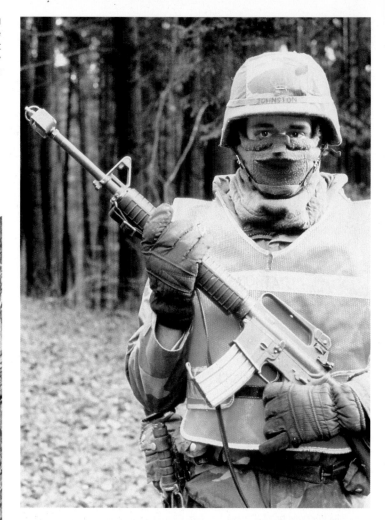

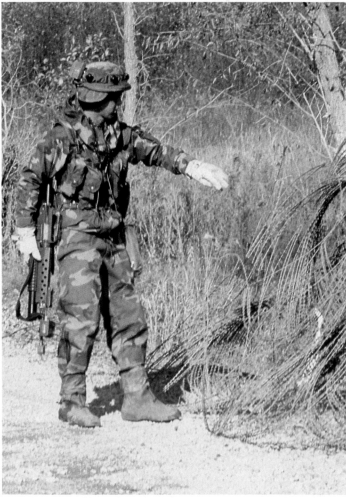

Wearing special waterproof mud boots, a 10th Division grenadier, armed with an M16/M203 40mm assault rifle/grenade launcher weapon, prepares a barbed wire booby-trapped obstacle for an ambush. Note woodland BDU pattern ECWCS parka and heavy-duty work gloves that are also used for rappel/fast roping being worn.(Courtesy:R.D. Murphy/10th Mountain Division)

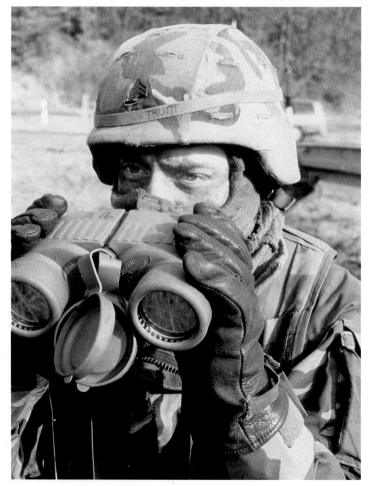

His face protected from the sub-zero cold by a woolen hat, a 10th Mountain sergeant gazes across an open field through his 7x50 Steiner M22 field glasses, before signaling his right arm in the air, and ordering his squad to proceed. (Courtesy:R.D. Murphy/10th Mountain Division)

A deputy regiment commander has a "sit down" with one of his charges, a rifleman, during a respite from exercises. Both soldiers wear woodland BDU pattern ECWCS winter jackets, and the officer carries a special maps case—in the BDU pattern, of course. (Courtesy: R.D. Murphy/10th Mountain Division)

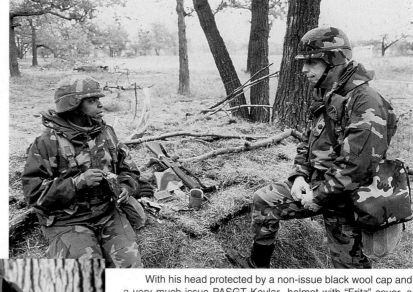

With his head protected by a non-issue black wool cap and a very much issue PASGT Kevlar helmet with "Fritz" cover, a 10th Mountain Division M249 light machine gunner pauses to catch his breath following a ten kilometer march through the inhospitable woodland country surrounding Fort Drum. Firing the same (5.56mm x 45mm NATO) .223 caliber round as the M16A2 (thus making it accessible to all troopers), the M249 has a maximum range of 3,300 meters (800 meters effective range) and a maximum cyclic-rate of 1,000 rounds per minute. At 15.6 pounds, its much lighter than the 23.1 pound M60 Medium Machine Gun, it gives the infantryman great versatility, and the squad with tremendous firepower. The M249 fires disintegrating metal link belts of 5.56mm ammo or 5.56mm in 30 round M-16 magazines. Thus, if belted ammo runs out, rifleman can keep "feeding" the LMG with 30 round magazines, or vise-a-versa. Ammunition inter-operability was last possible during the Korean War, when M1 Garand Main Battle Rifles and BAR light machine guns, belt-fed .30 caliber Browning M1917 medium machine guns all shot 7.62mm x 82mm ".30-06" cartridges. (Courtesy: R.D. Murphy/10th Mountain Division)

With the picturesque countryside blanketed by a dusting (by Fort Drum standards, anyway) of snow, 10th Mountain troopers blanket the roadway in a heavily armed patrol. They are one each side in single file, weapons facing outboard to respond to enemy ambush, though speed is deemed critical and the enemy threat low when road marching. (Courtesy: R.D. Murphy/10th Mountain Division)

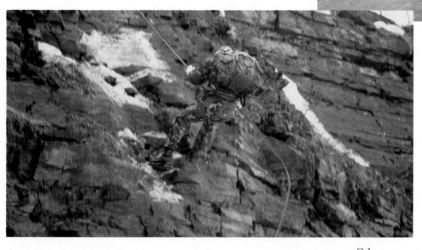

Wearing a three outer pocket medium ALICE LC-2 rucksack filled to capacity with explosive charges, a 10th Mountain sapper rappels using Army greenline rope down a snow capped gorge into the valley below for infiltration and demolition training. (Courtesy: R.D. Murphy/10th Mountain Division)

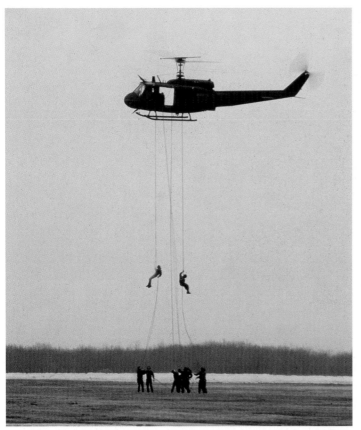

A brief respite in the weather affords the 14th Infantry Regiment a brief window in which to ply their skills at aerial rappelling; here, the mission executed from an aging UH-1H (Bell-212) workhorse. Fast Roping is faster since men do not need to tie Swiss seats and "hook up"; they slide down a fat fast rope like a fire pole with gloved hands. (Courtesy:R.D. Murphy/10th Mountain Division)

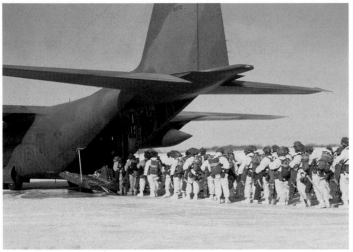

Originally, back in the days of World War Two, the soldiers of the 10th Mountain Division were know as "ski soldiers;" indeed, today the division is one of the only fighting forces in the U.S. Army's Order of Battle expert in the art of winter warfare in harsh snowy climactic conditions. 10th Mountain troopers, many of whom undergo Ranger training at Fort Benning, Georgia, are offered a treat on a sunny day in upstate New York—a static-line T-10C mass tactical parachute jump into the snowy woodlands around Ft. Drum courtesy of the cargo hold of an awaiting U.S. Air Force C-130 Hercules. With careful personnel selection, the Division could be filled with Airborne-qualified soldiers for an expedient parachute insertion capability. The Hercules can carry up to 80 paratroopers in a combat situation, 64 in regular conditions, 44 with in-flight rigging and 40 from the rear ramp. A more compact T-10D type parachute with reserve parachute piggyback on the main instead of separate on the chest would save valuable space for more paratroopers, simplify the jumping of combat equipment and improving safety. Snowshoes and skis can be easily jumped for over-snow tactical mobility. Snow mobiles and ETB/ATACs have yet to be tried for airdroppable snow mobility means. (Courtesy:R.D. Murphy/10th Mountain Division)

With an extra two feet of snow expected before nightfall, a M60E1 medium machine gunner does some "grounds-keeping work" at his forward firing position. This gunner is wearing a two-piece olive drab rubber wet-weather "gumby" gear. The "gumby" suit traps in sweat as readily as it keeps the rain out so soldiers that wear them when exerting are just as wet and at risk of hypothermia as if they stood in the rain! Impermeable rain gear must be carefully worn during times of limited exertion to prevent sweat build-up. His position has good overhead cover to protect from enemy artillery and to keep heat in for warmth! (Courtesy:R.D. Murphy/10th Mountain Division)

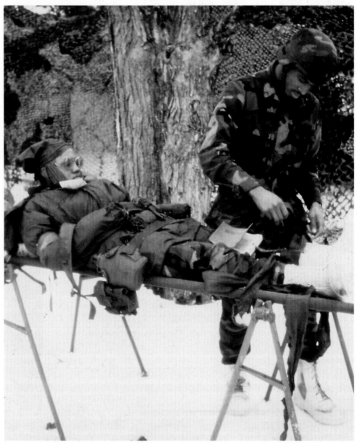

At a battalion aid station set up during large-scale divisional maneuvers, a corpsman from the 10th Mountain Medical Battalion determines the severity of a wounded soldier at the pre-operatory triage. Notice the stands to keep the casualty off the freezing ground where conduction can quickly sap all of his warmth. The UT 2000 Universal Transport and Carry System (UTACS) under evaluation by the Army's 10th Special Forces Group (Airborne) in use by the Austrian Army is a sled, cart, and litter that can be a 4-wheel gurney with a second set of wheels. It separates into two packboards when not used as a man/equipment carrier. Supplanting them are "Combat Life-savers" who are line infantry soldiers who have been given basic para-medic type training so injured soldiers have medical aid nearby, not just have to wait for medical personnel to arrive. The combat lifesaver can stabilized a wounded soldier's condition long enough for transport to a medical aid station and/or the arrival of a fully trained medic. (Courtesy:R.D. Murphy/10th Mountain Division)

All ready to head out into the four feet of snow in the woods outside of Fort Drum, a 22nd Infantry Regiment radioman poses for the camera, AN/PRC-77 and 100lb of "lightweight" extra gear, in tow. (Courtesy : R.D. Murphy/10th Mountain Division)

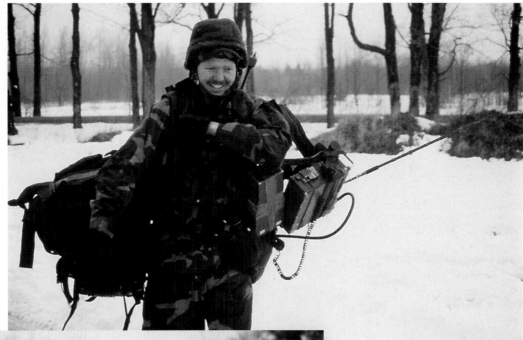

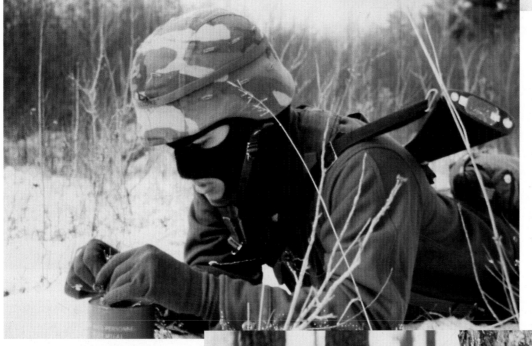

At a forward ambush perimeter, a sapper from the 87th Infantry Regiment prepares the fuse on an anti-personnel training "bouncing betty" mine which will soon be hidden by the expected snow. In U.S. service, Light Blue is the universal color for training rounds or dummy ordnance. The bottom of his M16A2 rifle stock shows the "trap door" for carrying a complete cleaning kit; another benefit of the full-sized M16 over its shorter M4 carbine brother.(Courtesy : R.D. Murphy/10th Mountain Division)

The capable survival skills of a 10th Mountain Division winter warrior is quite evident here, as the frigid and Spartan field conditions of a snowy battlefield are seen here to advantage. Beside being one of the most proficient American soldiers in winter and mountain warfare, 10th Mountain Division troopers are also survival specialists. Here, under tremendous snow fall and winds, a rifleman prepares his poncho to act as a one-man tent. Every U.S. Army soldier should receive in-depth survival, evasion, resistance, escape (SERE), individual equipment, and layered clothing wear technique instruction, in basic training not just air crew and Special Forces. It should be noted that the MWS (Mountain Warfare School) is in Jericho, Vermont, under the control and instruction of the 172nd Light Infantry Battalion, a unit also known as the "Avalanche Battalion."

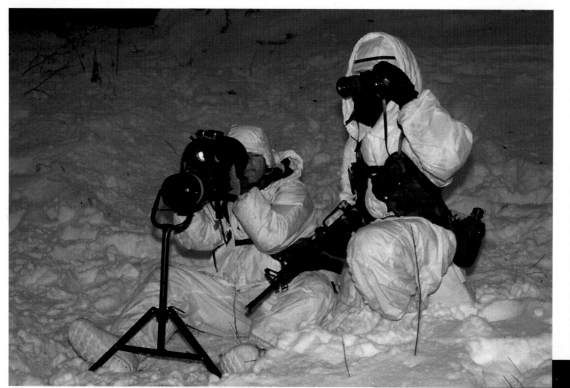

With the low moon and white blanket of snow on the ground providing unbeatable camouflage to those who are properly equipped, a 10th Division Dragon team, prepares to engage a valley full of targets. The snow troopers are armed with M16A2 Assault Rifles, an M47 Dragon ATGM, and their gear is carried in woodland BDU pattern TLBVs; they wear white cold-weather coveralls over their BDU pattern camouflage fatigues. The Dragon missile will drop 6 inches after leaving the launcher, using thruster rockets to remain airborne and make course corrections. The gunner keeps the cross-hairs on the target as the missile unreels control wires which feed signals to the missile's microprocessor. Careful aim must be taken to not fire over water, through trees. (Courtesy: R.D. Murphy/10th Mountain Division)

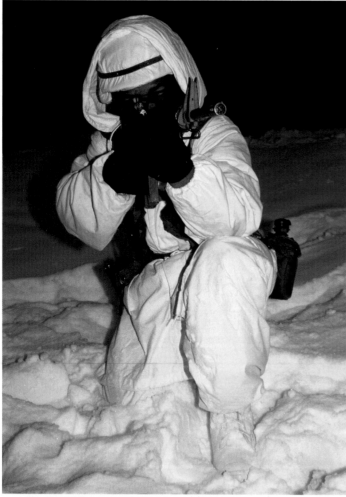

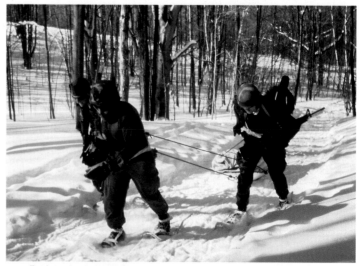

Virtually indistinguishable from the surrounding snow-capped hills, a 10th Mountain rifleman crouches down and takes aim with his M16A2 5.56mm assault rifle during small unit maneuvers. The 10th Mountain Division, as is perfectly illustrated by this trooper in his snowsuit, are among the only American soldiers proficient in winter and mountain warfare—the type of which is currently being waged in Bosnia. (Courtesy: R.D. Murphy/10th Mountain Division)

During shock assault exercises where they are forced to hurry about from objective to objective and stay one step ahead of the forces they are attacking, "scouts" from 1/22 10th Division (wearing special cold weather coveralls) carry their gear, rations, and ample supplies of C-4 on an improvised sled/stretcher. The only thing standing out is their olive drab green LBE which would be better if in a BROWN color. (Courtesy: R.D. Murphy/10th Mountain Division)

Originally known back in World War Two as the "Ski Soldiers" for their operations in the Italian theater, the 10th Mountain Division continues its heritage of training its personnel to move freely through snowbound terrain while laden down with combat gear. This photograph shows to advantage the 10th Mountain Division's unique ITLBV, and the white protective cold-weather snowsuit worn in harsh climactic conditions. (Courtesy: R.D. Murphy/10th Mountain Division)

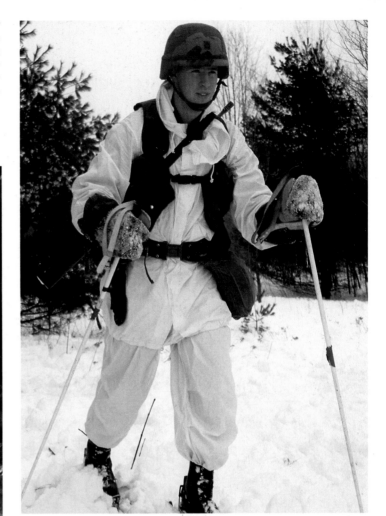

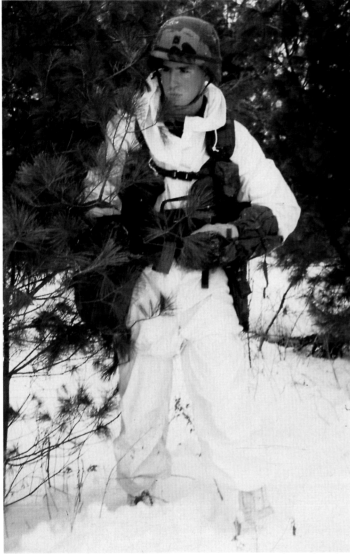

Should America become militarily involved in Bosnia, most military experts agree that the 10th Division is the likeliest unit that will be despatched to the Balkan hell. As pictured here, division riflemen in protective winter clothing undergo patrol and counter-insurgency training. (Courtesy: R.D. Murphy/10th Mountain Division)

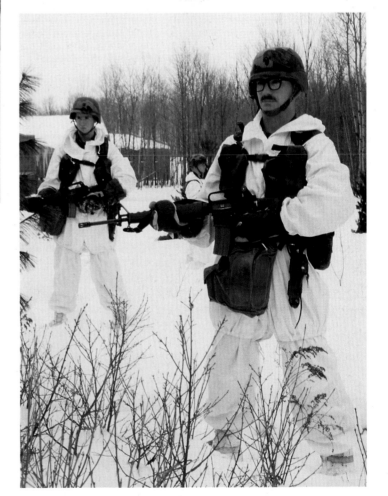

Perfectly camouflaged among the snow and trees that engulf the area around Fort Drum, a 10th Mountain rifleman cautiously advances through the hillside while conducting a search-and-destroy exercise; with the possibility of American involvement in the shattered remnants of the Yugoslav republic growing more likely in the near future, such expertise is crucial. (Courtesy: R.D. Murphy/10th Mountain Division))

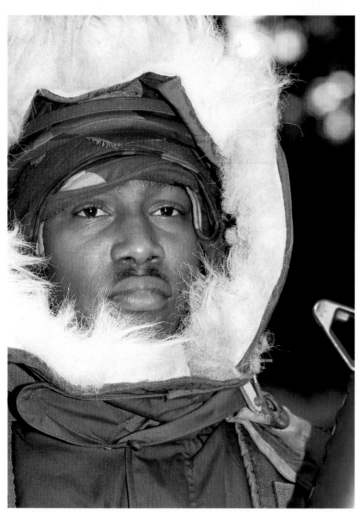

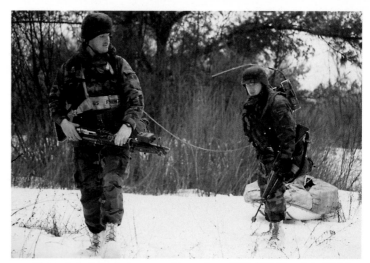

Through heavy winds, a scout team from 1/22 10th Mountain Division including an M60 gunner and a radioman (they are employing the buddy system of being hooked to a line for security) make their way up a peak to assume an advantageous firing perch overlooking an advance route. Note TLBV equipment worn by both soldiers. (Courtesy: R.D. Murphy/10th Mountain Division)

Camouflage is the key to successful infiltration operations in snow and cold-weather conditions, and camouflage is a skill taught with remarkable precision at the 10th Mountain Division. But even these experts are limited some-what by what they are issued; issue olive drab LBE still stands out from Arctic overwhites. (Courtesy: R.D. Murphy/10th Mountain Division)

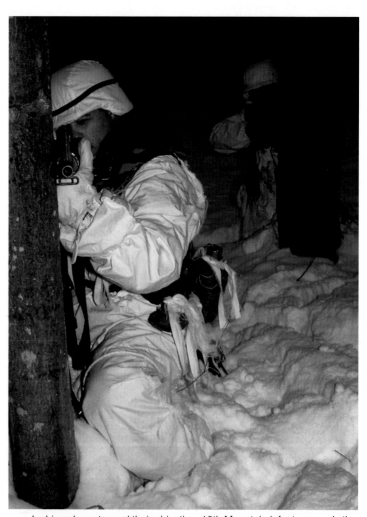

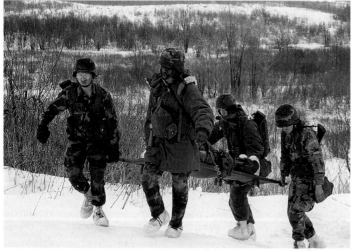

Corpsmen from the 10th Medical Battalion, all wearing special cold weather snow shoes, carry a wounded comrade to the battalion aid station, and a medevac flight back to hospital. Stretcher-carry is man-power intensive; one injured soldier can remove another 3 men from the battle for transport duties. An oversized tire all-terrain cart and sled like the UTACS would reduce this requirement and speed the transport of wounded soldiers to safety. (Courtesy: R.D. Murphy/10th Mountain Division)

Inching closer toward their objective, 10th Mountain infantrymen ply the skills of combat experienced foot soldier—move forward, take cover, creep closer to the killing zone and await the order to fire. (Courtesy: R.D. Murphy/10th Mountain Division)

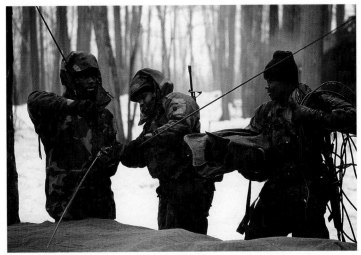

"Scouts" from 1/22 10th Mountain gather their gear and rope prior to setting out on a recce mission behind enemy lines during large-scale offensive exercises. Note black wool watch caps, worn primarily by recon and scout troopers, but a popular item worn by most division personnel. Wool keeps its insulating value even when wet.(Courtesy: R.D. Murphy/10th Mountain Division)

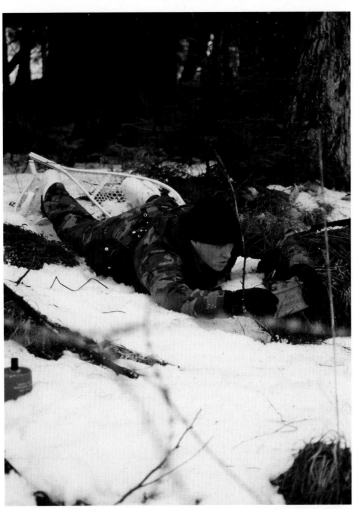

A scout "commando" from the 1/22, one of the division's "elite" formations, crawls with snowshoes through the snow unseen by enemy forces and prepares a training-aid Blue M18 Claymore mine in an ambush during maneuvers. Note back portion of TLBV seen here to advantage. (Courtesy: R.D. Murphy/10th Mountain Division)

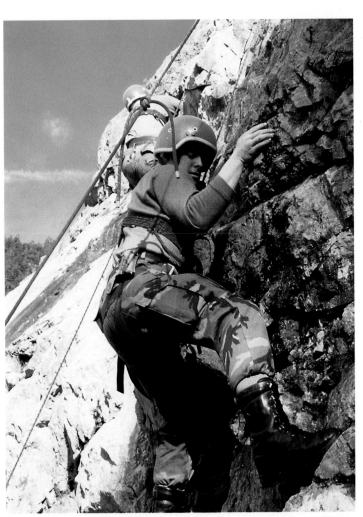

Objectives must be achieved no matter where they are—on a cliff side in the Bavarian Alps, 10th Mountain troopers learn the art of rappelling under some of the most difficult conditions around. (Courtesy: R.D. Murphy/10th Mountain Division)

During joint-NATO maneuvers, scouts from 1/22 are readied for a quick downhill descent with rappelling gear, by comrades in arms and ropes—mountain warriors from Germany's famed 1st Mountain Division, 23 Gebirgsjägerbrigade (still wearers of the world-famous Edelweiss emblem). (Courtesy: R.D. Murphy/10th Mountain Division)

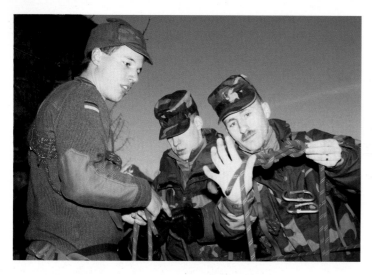

The art of roping and knotting is examined by two allied experts—a sergeant from the 10th Mountain Division, and a comrade from the German 1st Mountain Division. Note BDU-pattern winter ECWCS Gore-Tex parka worn to protect against the harsh Bavarian winter's chill. Gore-Tex was invented by the late William Gore from Teflon coatings as a breathable wind/rain proof membrane that can be added to outdoor fabrics. The fabrics themselves must be waterproofed so as to not soak up water and hold it against the Gore-Tex membrane. (Courtesy: R.D. Murphy/10th Mountain Division)

A joint 23 Gebirgsjägerbrigade and 1/22 10th Mountain patrol negotiates a mountain path in the Bavarian Alps during joint-maneuvers. Such international cooperation between "similar" elite units was considered crucial in the overall scheme of NATO's defensive and offensive strategies. That same international cooperation will be crucial in executing successful peace-keeping and humanitarian missions, like the division's participation in "Operation Restore Hope" in Somalia, and in "Operation Uphold Democracy" in Haiti. (Courtesy: R.D. Murphy/10th Mountain Division)

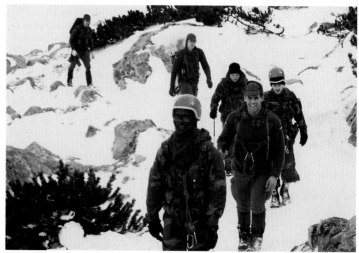

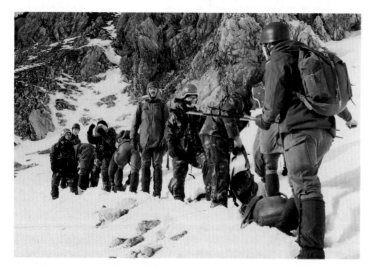

This photograph of 23 Gebirgsjägerbrigade and 1/22 10th Mountain personnel negotiating a mountain path clearly displays the gear and equipment carried by both sides to advantage. The mountaineering harnesses worn could be omitted if the TLBV had built-in life support hook-up points. (Courtesy: R.D. Murphy/10th Mountain Division)

A squad of infantrymen ready their gear and MRE (Meals-Ready-Eat) rations for several days in the snow and cold at Fort Drum. Note white winter snow suits, and stack of snow shoes ready for distribution. Towing equipment in a stretcher/sled apparatus is not only the most effective means for transporting large supplies of equipment in snowy terrain, but can also be used to transport a hurt or wounded comrade. (Courtesy: R.D. Murphy/10th Mountain Division)

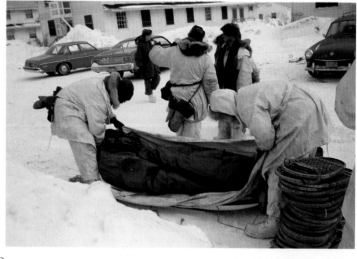

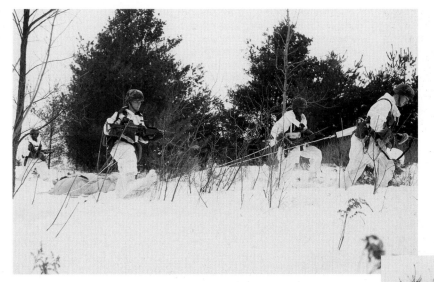

A squad of infantrymen from 3/14, 10th Mountain Division, ferry their week's rations courtesy of a modified "ahkio" sled and stretcher apparatus. Note issue white top/bottom coveralls, PASGT Kevlar "Fritz" pattern helmets, and squad gunners carrying the M249 SAW 5.56mm light machine gun—a weapon that has more than proven itself a worthy supplement and in some cases, successor to the M60 family of 7.62mm medium machine guns. The negative camouflage effect of their olive drab web gear and black weapons is evident here; the black outline of their weapons can be broken up with white tape, though their LBE will need to be produced in a more neutral universal BROWN color from the factory. (Courtesy: R.D. Murphy/10th Mountain Division)

Rear view of 3/14 troopers carrying their gear on the transport sled "ahkio" apparatus. Photograph offers an excellent view of the rear section of the woodland camouflage 10th Mountain TLBV personal equipment, which would be better in a BROWN color for Arctic and desert deployments. (Courtesy: R.D. Murphy/10th Mountain Division)

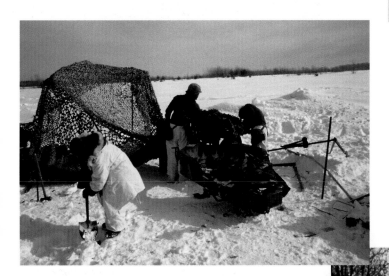

Anti-aircraft gunners from the 62nd Air Defense Artillery Battalion dig in and prepare their M167A2 20mm Vulcan gun for a day's full of "drone-destroying." The towed M167A2 is mounted on a single axle M42 carriage and fires linked 20mm cannon ammunition with 500 rounds at the ready. A 24-volt battery spins the M168 Gatling cannon barrels and another rotates the turret and operates the AN/PVS-2 range only radar. Both batteries are constantly recharged by an auxiliary power unit. (Courtesy: R.D. Murphy/10th Mountain Division)

Enduring sub-zero temperatures and wind gusts in excess of 50 miles per hour, a squad of 10th Mountain Division riflemen tug their gear up an embankment before bivouacking for the night. Wind chill can drive temperatures far below standing air areas, causing possible life-threatening effects. (Courtesy: R.D. Murphy/10th Mountain Division)

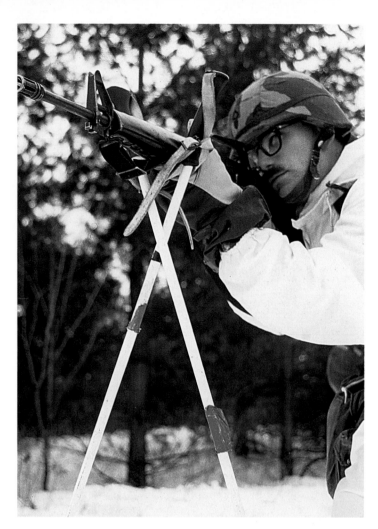

Ski poles are not just for cross country travel, but are also excellent anchors for steady firing. Ski soldiers just like their Second World War namesakes, 10th Mountain troopers are proficiently trained in cross-country skiing, and the art of combat deployment from skis. Norwegian soldiers have skis with a curved rear edge for backing out from a ski ambush position instead of the time-consuming "step turn" which exposes a soldier to enemy fire. This feature is being considered for U.S. military skis.(Courtesy: R.D. Murphy/10th Mountain Division)

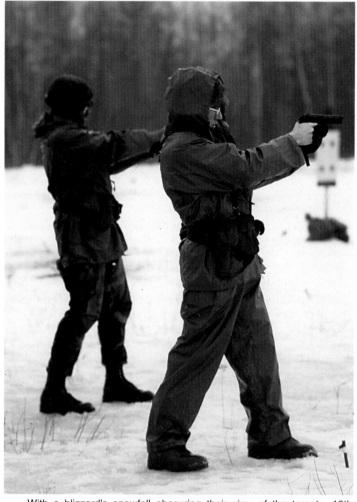

With a blizzard's snowfall obscuring their view of the targets, 10th Mountain NCOs and officers expend several magazine loads of 9mm ammunition and hone their skills with the (M9) Beretta 92SBF, carried in a M12 holster by Bianchi. Extra magazines held in M1 ammunition pouches. With an infinite amount of numbers to designate G.I. gear it is odd that a pistol pouch is given the designation "M1" which also happens to be the official designation of a 63-ton Main Battle Tank. The M9 is ambidextrous for left and right handed shooters with a decocking lever to lower the hammer for double-action carry. The .45 ACP has to be "sling-shot" loaded or cocked before firing unless one is willing to carry it "locked and loaded" with just a frame and grip safety preventing an accidental discharge. M882 9mm ammunition is inter-operable with our NATO allies. Army Special Forces that prefer the heavier .45 bullet for knock-down effect are procuring a new design offensive handgun with double-action capability. (Courtesy: R.D. Murphy/10th Mountain Division)

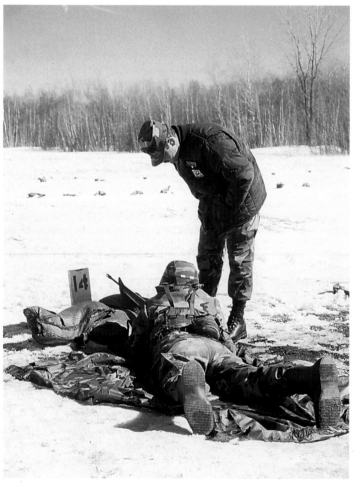

This photograph of a 10th Mountain rifleman on a firing range blanketed by an early winter's snow fall shows off the rear section of the TLBV to advantage. Note instructor wearing jacket liner. The M16A2 fires a heavier 62-grain bullet with steel core for body armor penetration requiring a faster turning one turn in seven-inch twist barrel for stabilization. This is in contrast to the old 55-grain M193 ball ammo fired through the M16A1's one turn in twelve-inch twist barrel. The M16A2 can shoot either old or new ammunition, while the M16A1 can only fire the old. (Courtesy: R.D. Murphy/10th Mountain Division)

The crew of a M167A2 20mm Vulcan gun from the 10th Mountain Division's 62nd Air Defense Artillery Battalion pose for their camera during a respite in live-firing exercises at Fort Drum. A BROWN color would be better universal camouflage for the gun, white tape and paint could be applied to blend the gun in better with the snow. (Courtesy: R.D. Murphy/10th Mountain Division)

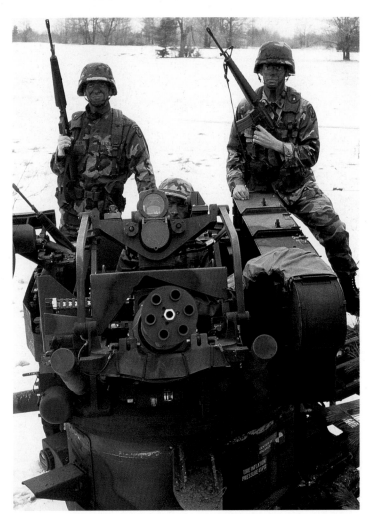

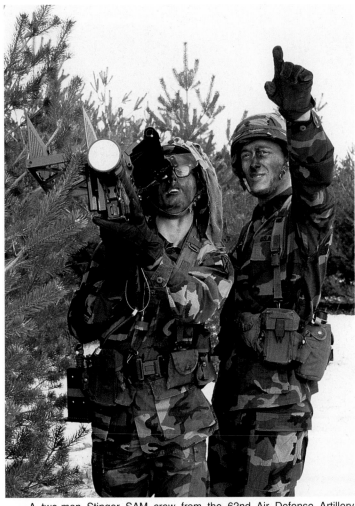

A two-man Stinger SAM crew from the 62nd Air Defense Artillery Battalion, emerging from their tree-lined camouflage cover, get ready to launch their warhead at a target drone. Woodland camouflage can still be effective in snow-covered areas if you stay under green vegetation.(Courtesy: R.D. Murphy/10th Mountain Division)

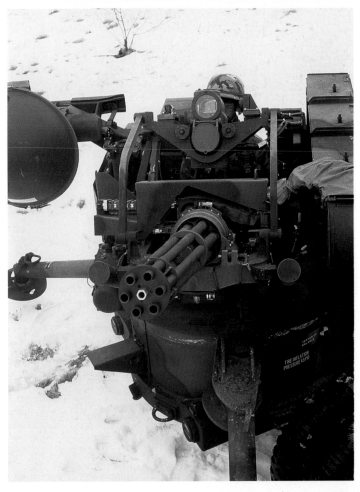

The business end of the deadly M167A2—the all-powerful 20mm Gatling cannon. Primarily deployed for air defense for unit deployment, the M167A2s are also extremely effective ground support weapons against encroaching enemy infantry and lightly mechanized forces. The M167A2 can be easily air-dropped, air-landed and towed over all-terrain by the 4x4 HMMWV. (Courtesy: R.D. Murphy/10th Mountain Division)

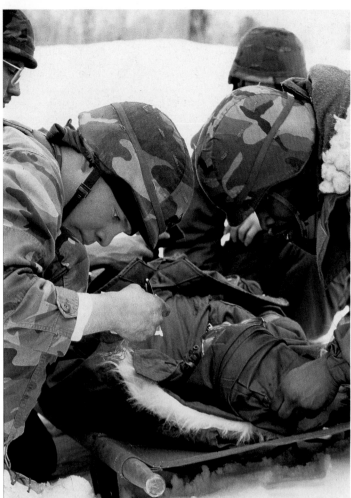

Corpsmen from the 10th Medical Battalion prepare a severely wounded comrade, hurt during maneuvers, for evacuation. Safety is constantly stressed in all training and operations. Soldiers are made to force water intake even in a cold weather environment to prevent dehydration and even heat injuries. This is because by the time you feel thirsty, the body is already very dehydrated. Clothing layers must actually be removed before marches, fighting position construction or high exertion activities to prevent heat build-up and sweat accumulation. (Courtesy: R.D. Murphy/10th Mountain Division)

As the regiment prepares to bivouac in the snow bound wilderness around Fort Drum, a 10th Medical Battalion corpsman assembles a portable stove that will be used as emergency frost bite rehabilitation center to cope with soldiers overcome by the frigid elements. (Courtesy: R.D. Murphy/10th Mountain Division)

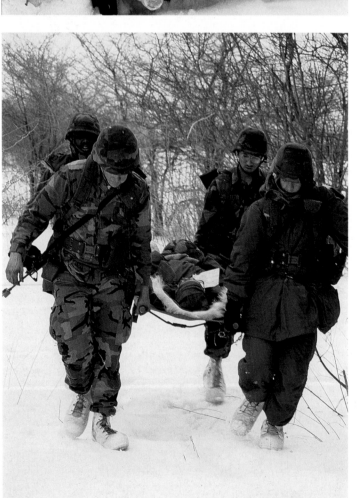

10th Medical Battalion corpsmen bear the stretcher of their wounded comrade in arms to an awaiting UH-60 Blackhawk and the medevac to hospital. A drop-in trauma/life support module needs to be developed to make Blackhawks into fully capable air ambulances as the IDF has done with twin-turbine engine Hueys. (Courtesy: R.D. Murphy/10th Mountain Division)

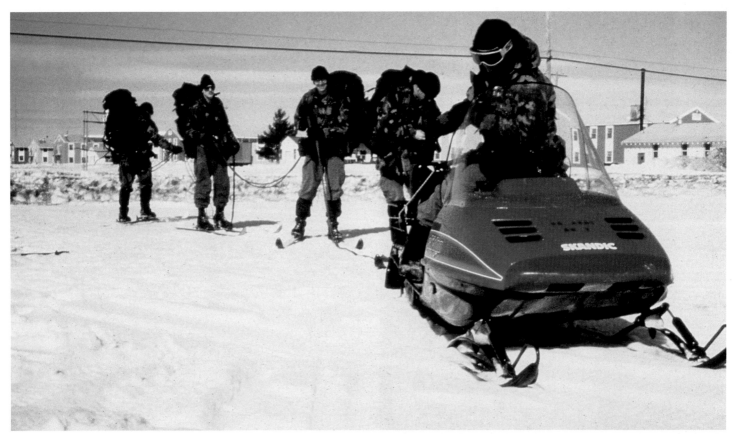

A piece of equipment not usually associated with a modern and extremely capable combat formation is the snowmobile, but the treaded speedster is an invaluable tool for the division's extended cross-country operations. Called MOST for Mobile Over Snow Tracked vehicle, the Polaris can go up to speeds of 100 mph, weighs 600 pounds and has a 200 mile range. The snowmobile depicted above will move soldiers behind on skis with a tow line; or "Skijoring." They complement Swedish Haaglunds BV 202 tracked Small Unit Support Vehicles (SUSV) in U.S. Army service. (Courtesy: R.D. Murphy/10th Mountain Division)

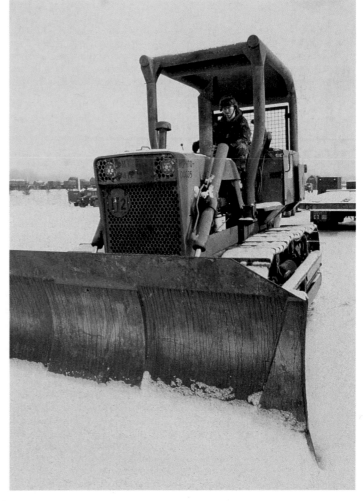

A divisional Small Emplacement Evacuator (SEE) cherry picker, used for unit position preparation, mobility/counter-mobility tasks, is enlisted for snow clearing duty during a particularly heavy blizzard around Ft. Drum; while such conditions might hamper the operations of another unit in the United States military, it is considered "ideal outdoor conditions" for the men—and women—of the 10th! (Courtesy: R.D. Murphy/10th Mountain Division)

A U.S. Army D7 tractor, in the typical camouflage pattern found at the division's home base at Ft. Drum, as well as in Europe, begins work on clearing the never-ending snowfall from the grounds at Ft. Drum. An expedient armor kit was developed for Desert Storm that can be applied for combat engineering work around enemy small arms threats and possible mines. (Courtesy: R.D. Murphy/10th Mountain Division)

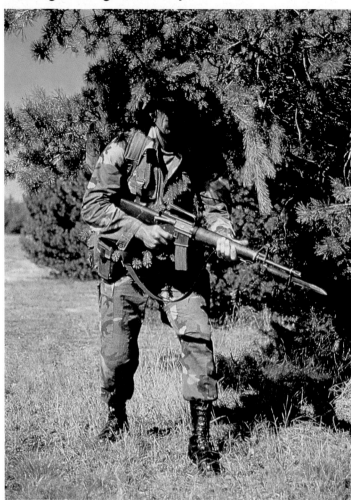

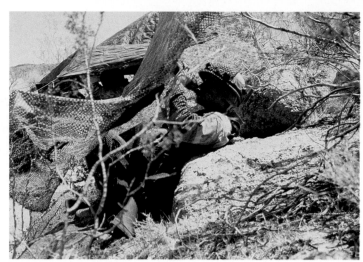

The art of camouflage—courtesy of the 10th Mountain Division (Part 1). After successfully completing the first segment of a 90 mile hike, a 10th Mountain grenadier replenishes his fluids at a forward staging area, well concealed by camouflage netting. (Courtesy: R.D. Murphy/10th Mountain Division)

One former Special Forces officer, a man who had spent much of his career operating invisibly in dangerous surroundings, once stated that "Few military formations in the U.S. Military—from Force Recon marines to Navy SEALs—are as adapt at blending in with their natural surroundings as are the men—and women—of the 10th Mountain Division (Light Infantry)." (Courtesy: R.D. Murphy/10th Mountain Division)

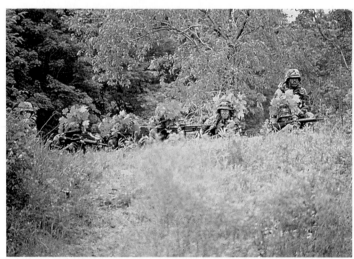

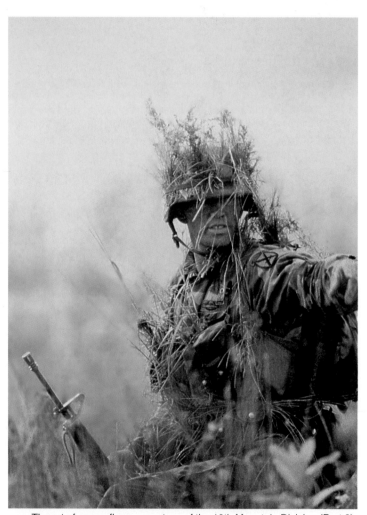

The art of camouflage—courtesy of the 10th Mountain Division (Part 3). With only their faces revealing them, a force of foliage-laden mountain troopers emerge from their well-concealed firing pit to unload several hundred rounds of 5.56mm fire from their M249s and M16s. It is obvious by the sequence of photographs featured here that the men of the 10th Mountain Division are among the most expert soldiers in the U.S. military in the "art of camouflage." (Courtesy: R.D. Murphy/10th Mountain Division)

The art of camouflage—courtesy of the 10th Mountain Division (Part 2). With the foliage of the Fort Drum area providing perfect camouflaging material, an NCO from the 10th Mountain Division's 110th Military Intelligence Battalion's LRSU (Long-Range Surveillance Unit) blends into the local terrain, making his movements virtually invisible to the enemy. Much like the role issued to U.S. Army LRRPs in Vietnam, the role of the 110th MID/LRSD is solely observation and surveillance—nevertheless, they are expertly trained in waging outnumbered fire-fights in order to break contact to return valuable information back to base. (Courtesy: R.D. Murphy/10th Mountain Division)

Wearing his MILES apparatus, a 7th Field Artillery spotter in full MOPP 4; (Mission-Oriented Protective Posture) NBC kit calls in by D-cell battery powered TA-312 field phone a 105mm barrage. He is underneath a "Depuy" fighting position with overhead cover. General DePuy was troubled by the casualties his 1st Infantry Division (Big Red One) took on forward slopes in Vietnam and devised an entrenchment system of positions with frontal/overhead cover firing obliquely to support each other with interlocking fire. Its now Army-standard, though the marines still have doctrinally no method for overhead cover; they still dig open, exposed fighting holes. Another defensive option is the reverse slope defense used brilliantly by the British Parachute Battalions/Royal Marine Commandos in the Falklands War. Their observation of Argentine defensive positions: "we were glad they were U.S. style forward-slope positions so we could pour tons of fire onto them before we assaulted, saving our boys lives". (Courtesy: R.D. Murphy/10th Mountain Division)

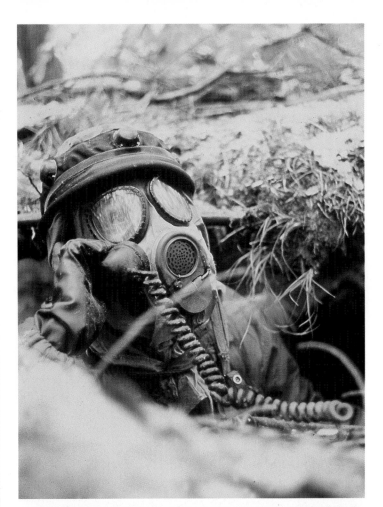

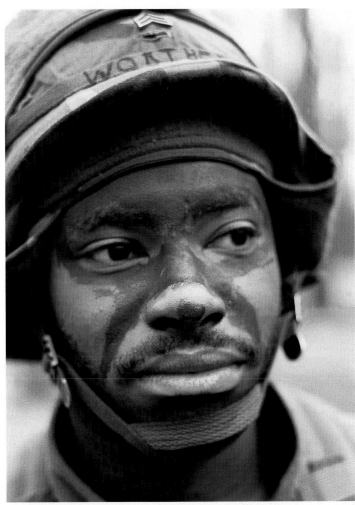

Well-camouflaged for an ambush in the woods, a 10th Mountain Division rifleman awaits inspection before heading out into the field. (Courtesy: R.D. Murphy/10th Mountain Division)

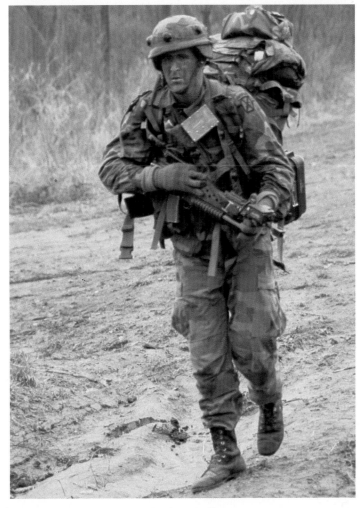

We are taking fire....hurry! During simulated combat exercises, a laden-down grenadier from the 2/22 10th Mountain Division attempts to fall into firing position before his MILES system will buzz. In maneuvers, the flexibility of doing it one more time always exists. No such luxury exists in the field—be it in the KTO or in Somalia. (Courtesy: R.D. Murphy/10th Mountain Division)

Soldiers from the 10th Mountain Division (Light Infantry) patrol along the perimeter of Keystone Airfield, in Saint Mary's Georgia, during exercise Sand Eagle '89 as part of the Rapid Deployment Force response maneuvers. Note gear stowed in troopers backpack. (U.S. ARMY)

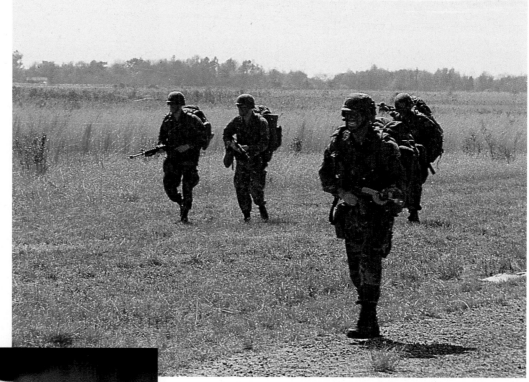

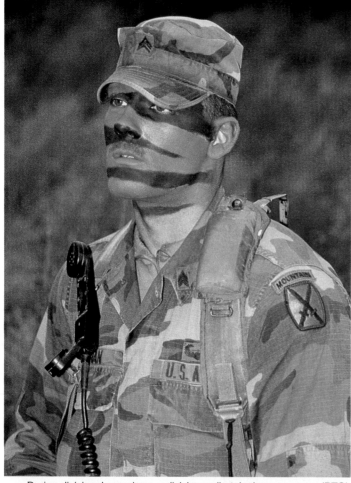

During divisional exercises, a division radio telephone operator (RTO) displays his unique and effective camouflage skills. Note BDU pattern Ranger "Patrol Cap" worn, as well. The cap is slightly stylized after the Civil War "forage" cap and has ear warmer flaps that are a clever and effective feature, though rarely used except for survival emergencies due to cosmetic reasons. Water repellency is marginal and many soldiers spray waterproof coatings to improve rain performance. The beads on his left LC-2 shoulder strap are for pace counting. Soldiers buy them from military clothing sales stores using private purchase initiative or make field expedient models using Type III "550" parachute cord. (Courtesy: R.D. Murphy/10th Mountain Division)

At Fort Drum, New York, a member from the 110th Military Intelligence Battalion/LRSU (Long-Range Surveillance Unit), deploys a AN/PSC-3 satellite transmission SATCOM device. Note maroon beret, which all 110th/LRSD personnel are permitted to wear since they are static-line and sometimes military free-fall parachute qualified in order to infiltrate into a named area of interest (NAI) to collect intelligence. (Courtesy: R.D. Murphy/10th Mountain Division)

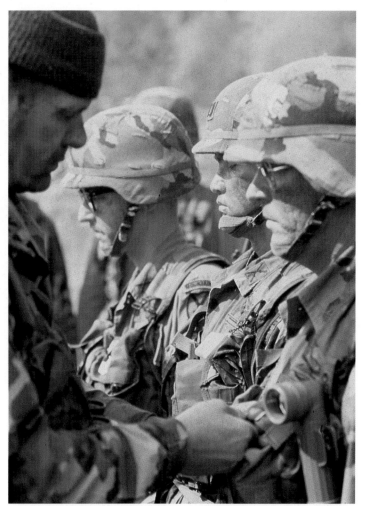

A by-product of the Iraqi invasion of Kuwait and subsequent march to war was the threat of civil unrest (protests that never transpired) and terrorism (a threat that, due to classified information, has never been fully publicized). Bracing for any eventuality, 10th Division troopers fetch their riot shields and clubs for a drill. A lightweight ceramic/clear polycarbonate ballistic protective "gun shield" could be fitted to the M16 barrel/bayonet lug to provide protective cover when soldiers peer out to fire their weapons and maneuver on the enemy; using IMT: individual movement techniques. (Courtesy: R.D. Murphy/10th Mountain Division)

Divisional officers and NCOs undergo an inspection from the division's deputy commander prior to the commencement of large-scale combat maneuvers. Note clumsy MX-199U anglehead flashlight precariously clipped to the soldier's LBE; its slated to be replaced by a smaller, more durable mini-mag-type flashlight. Many soldiers use private purchase initiative (PPI) to obtain their own red-lensed mini-mag flashlights to contribute to their own mobility/mission accomplishment. (Courtesy: R.D. Murphy/10th Mountain Division)

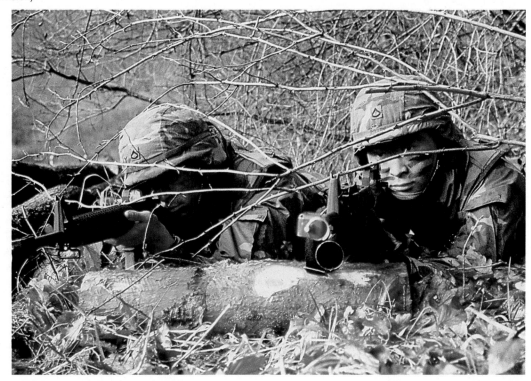

Camouflaged perfectly behind a fallen log and the winter's underbrush, a grenadier team takes cover before being the issued to fire! Note the red blank firing adapters (BFAs) on their weapons; necessary for the MILES coded laser to fire. (Courtesy: R.D. Murphy/10th Mountain Division)

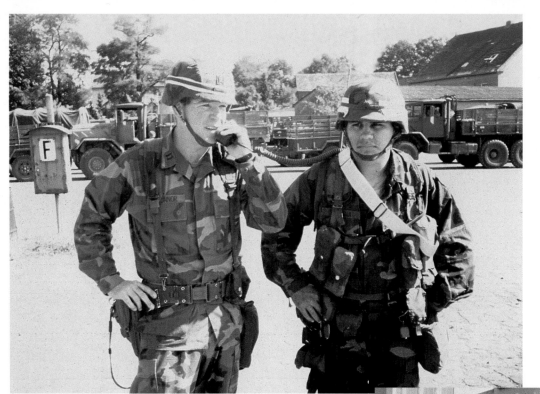

An officer and his trusted radioman confer with the advanced element of the company already in the field. Note subdued captain's bars, and M11 holster for his Beretta. The woodland BDU comes in nylon/cotton winter and cotton ripstop summer weight version. The heavier version offers negligible warmth improvement over the summer weight but much greater absorption and retention of water/sweat-a hypothermia risk. Both uniforms suffer from excessive heat trapping from unnecessary pockets, buttons and straps. The shirt lower pockets could be omitted since LBE blocks their use, allowing the tail to be tucked in for rappelling, mountaineering, parachuting and a more professional appearance in garrison. (Courtesy: R.D. Murphy/10th Mountain Division)

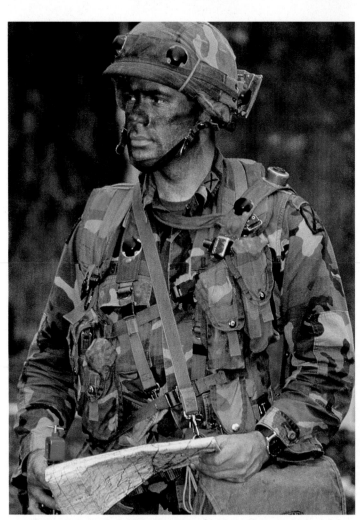

Stoic portrait of a 10th Mountain Division rifleman—Light Infantry embodied in the determination and courage of the force's fighters. This officer wears the division's unique individual Tactical Load Bearing Vest, and is equipped with the MILES apparatus for the commencement of the realistic, though safe, maneuvers. (Courtesy: R.D. Murphy/10th Mountain Division)

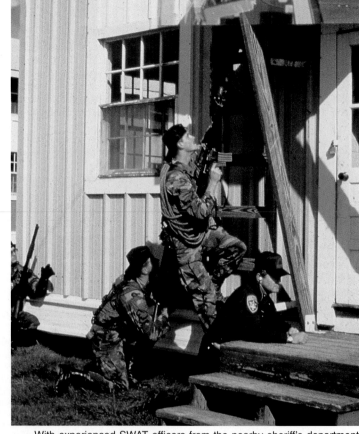

With experienced SWAT officers from the nearby sheriff's department watching on , MPs turned commandos from the division's Military Police Company receive advance urban assault and hostage rescue training; this was instruction geared for the possibility of terrorist attacks during the Gulf War, and was most useful during the division's recent deployment to Somalia in "Operation Restore Hope." Note trooper, far left, armed with a 12-gauge pump action shotgun, excellent for blowing locks/door knobs off with slugs and room clearing with "OO" buckshot. (Courtesy: R.D. Murphy/10th Mountain Division)

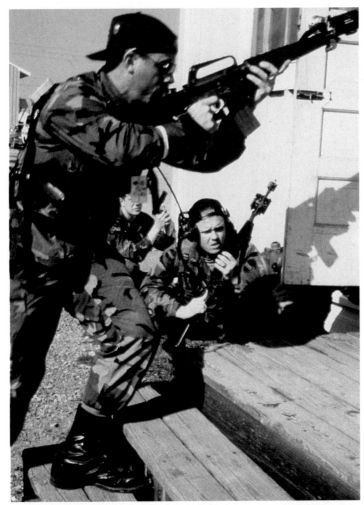

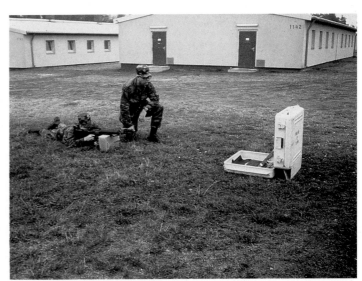

Although renowned throughout the U.S. military for their marksmanship skills, there is always room for improvement. Here, a division light fighter receives some laser-enhanced sharp-shooting instruction to battlesight-zero (BZO) his MILES emitter on his M16 assault rifle from a seasoned, and highly expert teacher. (Courtesy: R.D. Murphy/10th Mountain Division)

The order has been given....time to fight room-to-room! 10th Mountain Division MPs put into fruition the hostage-rescue assault training they had received; note troopers, (background) with M9 pistol drawn. The point man in CQB (Close Quarter Battle) usually has a pistol for one hand to be free to toss stun grenades, open doors etc. as well as selectively engage enemies. (Courtesy: R.D. Murphy/10th Mountain Division)

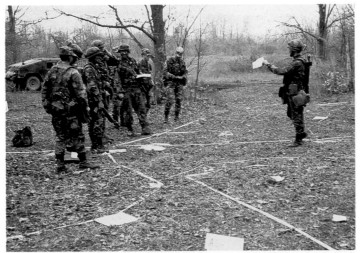

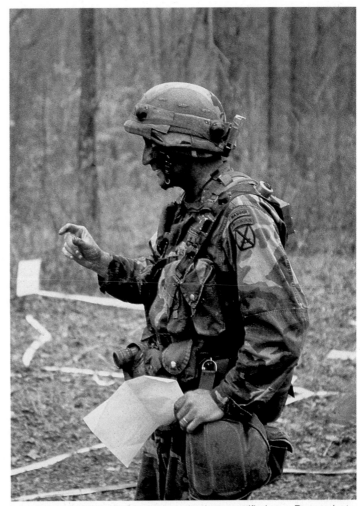

With the battalion "Humvee" in the background, officers and senior NCOs from the 14th Infantry Regiment, scrutinize their field map and receive their orders. A large sand table allows the mission to be "walked through" by key leaders to include "what if" questions on how to react against possible enemy actions. Written operations orders are best communicated alongside a terrain model, sketch or at least a marked map or overlay so soldiers can visualize mission actions. "War-gaming" in this way is a form of "Mission Preview" that all good leaders do during the mission analysis troop leading step prior to forming the final operations order. Note faces camouflaged, and ready for action. (Courtesy: R.D. Murphy/10th Mountain Division)

A 10th Division officer, who has also been certified as a Ranger (note Ranger tab), gives his final instructions to his immediate command circle before his company begins an assault course exercise. He is equipped with the MILES apparatus, and wears the division's ubiquitous TLBV gear. Because of its unique capabilities, and the army's desire to raise the level of combat proficiency in the division, they have encouraged officers and NCOs alike to take the arduous and difficult Ranger course, as well as to serve with the Rangers for several tours. (Courtesy: R.D. Murphy/10th Mountain Division)

AND AMBUSH........! His fears correct, the radioman hits the ground to find cover in the natural camouflage of the fall foliage around Fort Drum. Concealment is protection from just enemy observation; cover is this plus protection from enemy FIRE. (Courtesy: R.D. Murphy/10th Mountain Division)

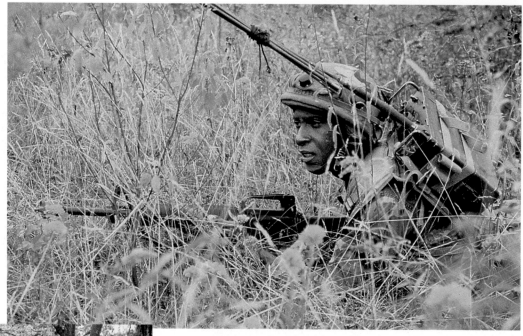

Excellent portrait of a typical division field bivouac, as seen during recent exercises at Fort Drum, New York. Note the superb group camouflage blending in with the surrounding woods. The new Five Soldier Crew Tent (FSCT) is now Army-common and is depicted in the foreground. (Courtesy: R.D. Murphy/10th Mountain Division)

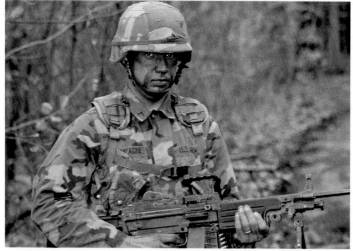

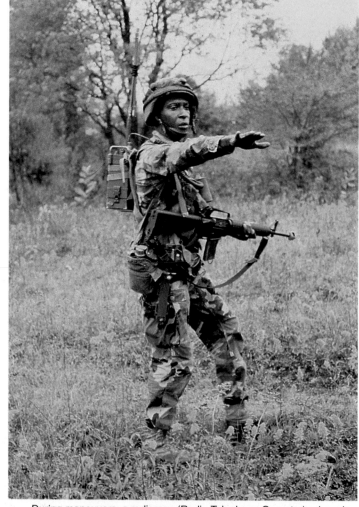

Close-up view of a 10th Mountain SAW light machine gunner, with his weapon, BDU fatigues, and individual Tactical Load Bearing Vest. Note subdued Private first-class rank insignia on his collar. His helmet cover has slots to insert vegetation for camouflage effect. A new 3-point simplified PASGT Kevlar helmet suspension band/chinstrap is now available from Gentex of Carbondale, Pennsylvania; makers of the legendary "Fritz" helmet. (Courtesy:R.D. Murphy/10th Mountain Division)

During maneuvers, a radioman (Radio Telephone Operator) advancing through the bush relays a warning by hand/arm signal to the other men to move with caution as the threat of an ambush is apparent. His AN/PRC-77 whip antennae is tied in segments for ease of movement through dense foliage but can be quickly untied and linked together to form a tall antennae with better reception/signal propagation. The links are connected by a tension cord. Note MILES apparatus in place. (Courtesy: R.D. Murphy/10th Mountain Division)

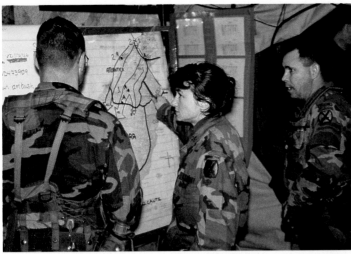

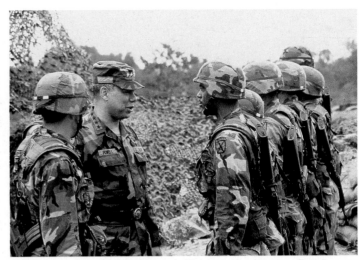

During exercises in the frozen terrain around Ft. Drum, a female officer briefs one of the mountain soldiers, as the pre-planned battle progresses. Like all other non-combat units of the U.S. military, women have assumed equal and all-important tasks in the division's combat support and support units in the U.S. Army's Order of Battle. (Courtesy: R.D. Murphy/10th Mountain Division)

Soldiers from the 10th Mountain Division's Headquarters Battalion are treated to an inspection by one of the most popular Chairman of the Joint Chiefs of Staff (JCS) in U.S. military history: Lieutenant-General Colin Powell. (Courtesy: R.D. Murphy/10th Mountain Division)

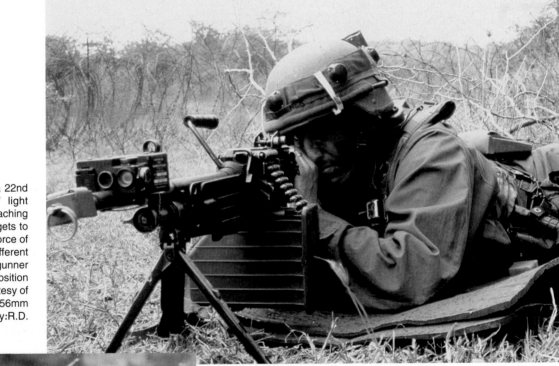

Positioned on a low ridge, a 22nd Infantry Regiment M249 SAW light machine gunner scans the approaching country in search of potential targets to place within his sights—when a force of infantrymen (soldiers from a different company) are spotted, the SAW gunner flattens himself in perfect firing position and prepares the simulated (courtesy of the MILES apparatus) volley of 5.56mm fire for their destruction. (Courtesy: R.D. Murphy/10th Mountain Division)

Looking more like jungle troopers and the mountain warriors, a squad deploys into the woods near Fort Drum during maneuvers. Note telephone-like radio handset strapped in the soldier's "Fritz" helmet chin straps for hands-free radio monitoring and weapons handling. The handset is muffled from inside the helmet for better stealth than hooked exposed on the LBE. (Courtesy: R.D. Murphy/10th Mountain Division)

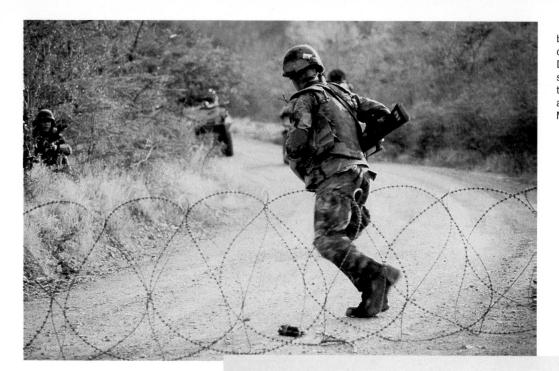

The art of the ambush! With a barbed wire obstacle in place in the center of the only road between Fort Drum and the "Blue Squad's" objective, soldiers from the "Red Squad" race into the adjacent bush ready for the approaching enemy. (Courtesy: R.D. Murphy/10th Mountain Division)

Excellent view of the equipment worn by the modern 10th Mountain Division trooper: of particular interest is the rear view of the soldier ALICE gear, "Cats Meow" sleeping bag positioned on the back, and the MILES receiving device worn on the back of the helmet. Note the smaller, though less effective tape antennae fitted to the field radio. (Courtesy: R.D. Murphy/10th Mountain Division)

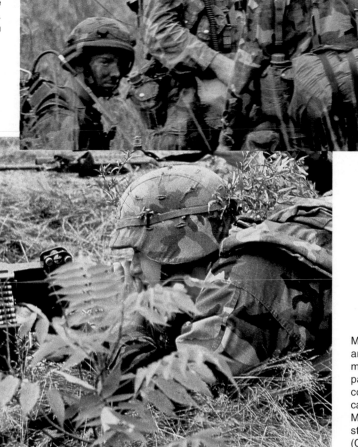

Excellent photograph of a 10th Mountain Division machine gunner—and the M249 SAW 5.56mm light machine gun—in action. New paratrooper models will have a compacting stock and folding carry/barrel change handle for carry in M1950 unmodified weapons cases for static-line parachute jumping. (Courtesy: R.D. Murphy/10th Mountain Division)

Causing the earth to shake below him, a soldier from the 62nd Air Defense Artillery Battalion, a FIM-92 Stinger SAM operator pulls the trigger back on his system and allows the 8.2 kilogram missile to propel itself toward its soon to be obliterated drone target. The Stinger is cold-launched to a safe distance before the main motor ignites, sending the missile on an infrared homing course on aircraft at speeds in excess of Mach 3. (Courtesy: R.D. Murphy/10th Mountain Division)

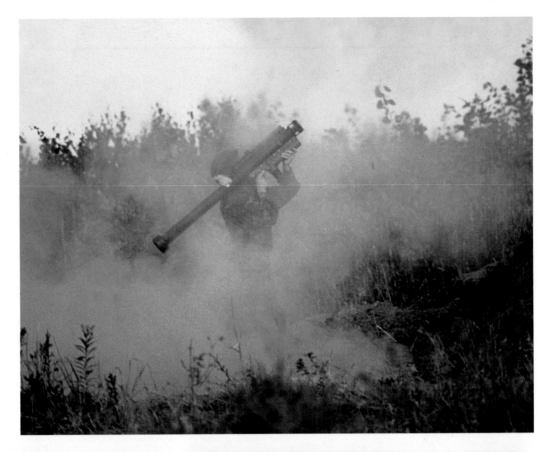

Stoic portrait of a 10th Division sergeant—the "blood and guts" that makes the division run!—inspecting his troops following a visit to the firing range. Note Ranger-style patrol cap worn, and sergeant's subdued stripes placed on cap. (Courtesy:R.D. Murphy/10th Mountain Division)

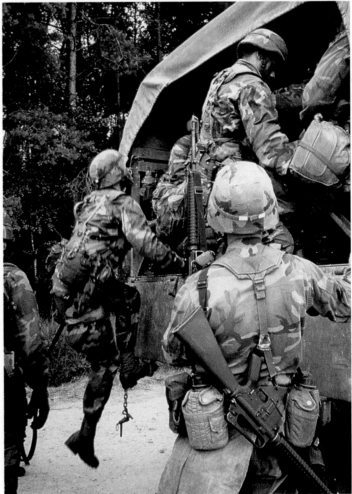

Excellent rear and side views of the personal gear—ranging from TLBV and ALICE gear—worn by 10th Mountain Division troopers as they board a M939 series 5-ton truck for a quick ride toward the battalion staging area. (Courtesy:R.D. Murphy/10th Mountain Division)

43

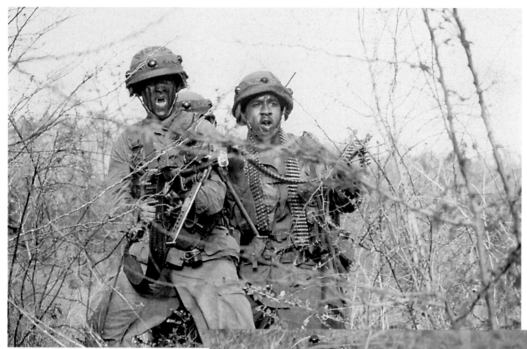

An M60E1 MMG team offers the best war cry they can muster; HOOAHH! before unloading an unremitting 6-9 round burst of blank fire during combat training. Should they, in fact, kill any of the enemy a deafening beam will sound from their MILES devices. Soldier thus hit, must take out their weapons key and insert it into his torso harness to get the sound stopped. A weak or dying battery will also kill a soldier in MILES gear, making fresh batteries a must before mock battle. Wounded/killed MILES soldiers go to a designated unit officer with a "green key" or to an observer-controller (OC) to turn their gear back on for another fight.(Courtesy: R.D. Murphy/10th Mountain Division)

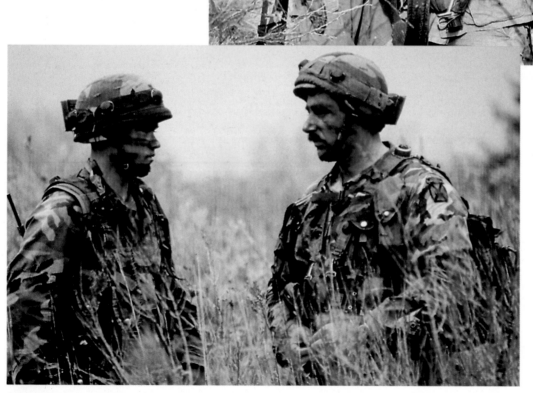

Two 10th Mountain Division officers, work out an operational challenge, as they attempt to seize an objective (a series of pillboxes held by soldiers from the 87th) before nightfall. A shock weapon like an in-Army-stock M40A2 106mm Recoilless Rifle mounted on a HMMWV like Honduras/Morocco have done can take out such positions from a safe stand-off distance preventing light infantry casualties from close range assaults. The bunker-busting power of the 106 has been proven from Korea, Vietnam and continues to this day. (Courtesy: R.D. Murphy/10th Mountain Division)

Dramatic photograph of a M47 Dragon ATGM seconds after having been fired using an ATWESS MILES simulator. As can be seen by the virtual invisibility of the soldier in the field, the ability for small units of soldiers to camouflage themselves in the woods with lethal hand-held weapon systems can more than make up for their numbers in inflicting damage and havoc to enemy forces. (Courtesy: R.D. Murphy/10th Mountain Division)

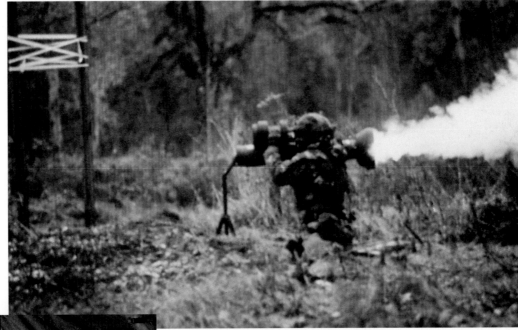

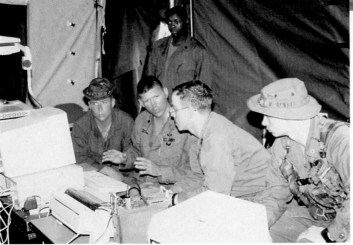

During warm weather training, several 10th Mountain riflemen and grenadiers view the results of the training, courtesy of a patient NCO, and a highly-powerful IBM computer. (Courtesy: R.D. Murphy/10th Mountain Division)

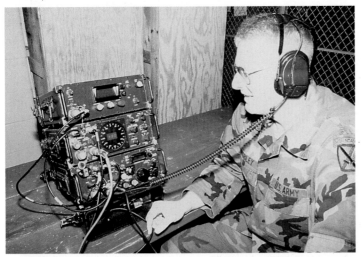

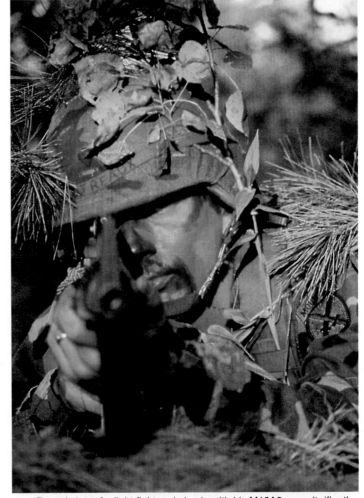

Maintaining a constant vigil with his elaborate AN/PRD-11 Direction-Finding gear, a 110th Military Intelligence soldier locates the various forces of the "enemy" in the field during combat maneuvers. The AN/PRD-10 family is being replaced by the AN/PRD-12 Lightweight Man-Transportable Radio Direction-Finding System (LMRDFS) which is deployed by two military intelligence soldiers and has a total weight of less than 45 pounds; 30 pounds less than the equipment depicted above. 6 AN/PRD-12s are issued to each light infantry division. (Courtesy: R.D. Murphy/10th Mountain Division)

Frontal view of a light fighter aiming in with his M16A2 assault rifle; the rifle no longer has holes on the bottom of the flash compensator to prevent kicked up dust from signaling his location to an alert enemy. Another addition needed would be a low-cost disposable silencer that could be fitted to the barrel that need only last for 30 rounds-one magazine so a soldier on a recon patrol could eliminate an enemy and break-contact with minimal signatures. These silencers could be issued for large behind-enemy lines raiding parties where a quick strike and get away are required to avoid enemy reinforcements. (Courtesy:R.D. Murphy/10th Mountain Division)

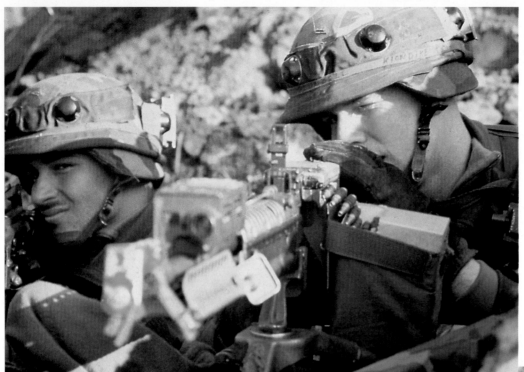

Letting his breath out in a slow and deliberate manner, a mountain trooper begins the very fast—and sometimes dragged out and methodical—process of squeezing on the trigger (of his M60) and letting loose a few hundred rounds of 7.62mm fire. Bursts of 6 or more insure reliable operation of the M60 MMG. (Courtesy: R.D. Murphy/10th Mountain Division)

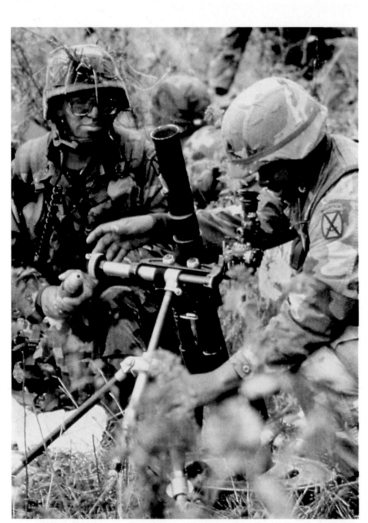

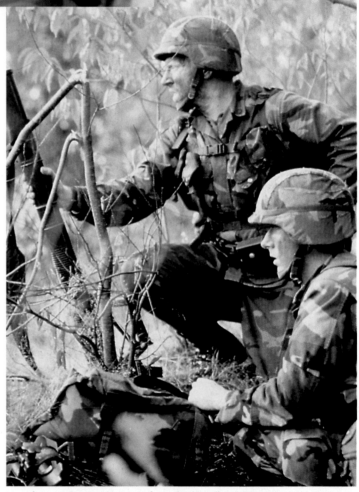

With a 60mm smoke round in hand, a two-man M224 mortar crew awaits the order to fire and lay down a covering barrage and allow the remainder of the battalion to proceed undetected. Each platoon deploys three 60mm mortars, providing the force with highly accurate and lethal "artillery" support wherever they deploy. Mortars provide indirect, plunging fire that can reach enemies hiding behind frontal cover too strong for small arms fire to penetrate. (Courtesy: R.D. Murphy/10th Mountain Division)

A two-man mortar team from the battalion weapons company set up their 60mm M224 mortar; the weapon can fire up to 20 rounds a minute. It can be fired in the hand-held mode, trigger-fired using the square M8 baseplate or drop-fired using the circular M7 baseplate and bipod. A composite material base plate in-between the size of an M8 and a M7 would be lighter than carrying two base plates while still offering assault and bipod fires. Aiming stakes are used by an optical collimator to dial in deflection and elevation adjustments from observed fire commands. Company-level mortars usually don't have a FDC; Fire Direction Center, though a small hand-held mortar computer like the British MORZEN could give this accuracy on the gun-line. (Courtesy: R.D. Murphy/10th Mountain Division)

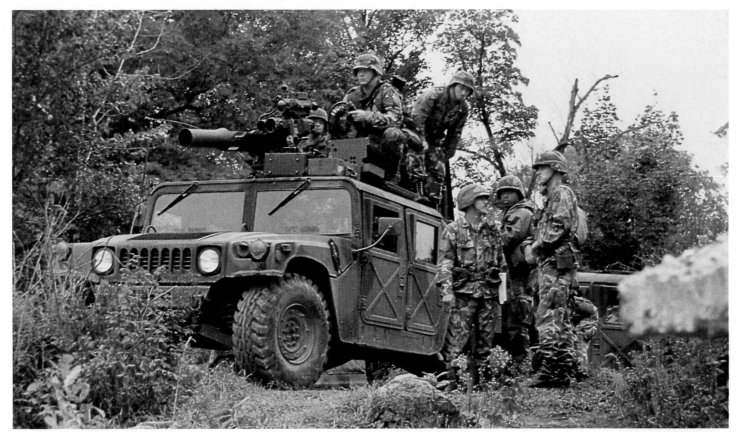

Fort Drum, New York. Members of 3rd Squadron, 17th Cavalry, 10th Mountain Division (Light Infantry) , prepare a tube-launched, optically tracked, wire guided (TOW) anti-tank missile launcher mounted atop an M-1045/1046 high-mobility multipurpose wheeled vehicle (HMMWV) during defensive exercises. TOW infrared "thermal" sights act as the eyes of the light infantry force detecting enemy presence long before image intensifiers can. Thermals can also detect disturbed dirt where mines may be buried. (U.S. ARMY)

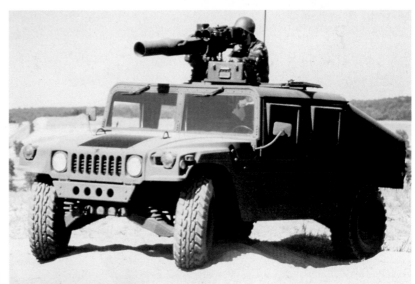

Side view of the M1045/1046 Humvee-TOW in 10th Mountain Division (Light Infantry) service. TOW HMMWVs are key elements of the Light Infantry Division's anti-armor plans, using their 3,750 meter stand-off range to ambush armor beyond the range of main battle tank main guns. As they displace to alternative firing positions, if the enemy armor force continues, it will slam into engineer created obstacles/minefields, where called artillery fire, helicopter gunship, USAF fighter air strikes, and organic Division mortar, rocket and missile fires can finish them off. (Courtesy: R.D. Murphy/10th Mountain Division)

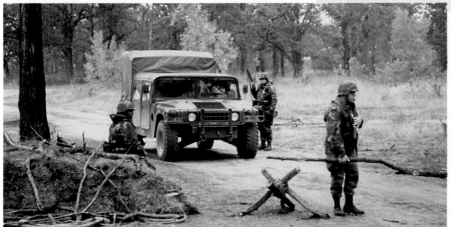

During war games, soldiers from the 22nd Infantry Regiment man a checkpoint, as they "examine" the passengers of an approaching "Humvee"—their weapons at the ready. AM General of Michigan makes the "Hummer". The Light Division has enough HMMWVs in its transport section to distribute one per infantry company to act as a liaison/resupply vehicle; usually towing a trailer full of 5-gallon black or tan colored plastic water jugs and MRE rations. Everything else must be carried on soldier backs! One of the reasons why a 1989 Army Command & General Staff College officer proposed in his master's thesis the use of modern All-Terrain "Mountain" Bicycles (ATBs) for Light Infantry mobility beyond foot march speeds. (Courtesy: R.D. Murphy/10th Mountain Division)

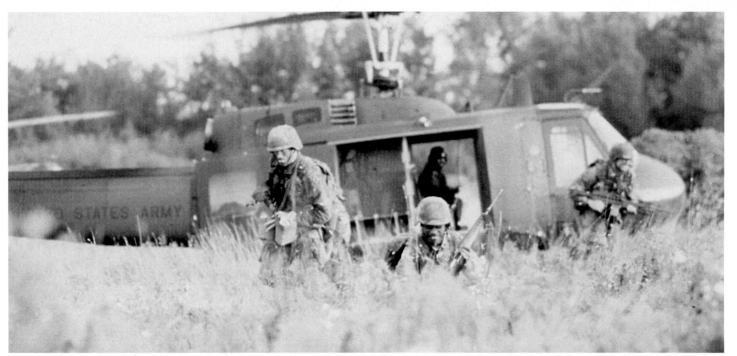

Although being phased out, a few "ancient" (Bell-212s) UH-1H Hueys still remain in service with the 10th Mountain Division's air cavalry battalion. The UH-1 was the Army's first turbine-powered helicopter in 1958. Hueys have been fitted with fuselage top/bottom wire cutters and the top cutter is visible here. The Hueys are in a well maintained condition as the author can personally attest. Hueys were recently provided to the Dominican Republic to assist in border security with troubled, next-door Haiti. (Courtesy: R.D. Murphy/10th Mountain Division)

Prior to a two-week long bivouac in the field that will include anti-tank training, a fleet of M1045/M1046 Humvee-TOW vehicles are prepared for their journey into the field. Having proven its worth in Operation Desert Storm as one of the world's most lethal anti-tank missiles, the TOW-family remains the mainstay AT weapon deployed by U.S. forces. TOW IIA has a tandem school warhead to defeat reactive armor, IIBs are to have a top-down attack warhead to keep capable against modern composite armors. A ground tripod mount is visible; the TOW can be man-packed for short distances; in some scenarios ground mounting to form a defensive strong point is better than trying to hid the TOW under the high silhouette of a HMMWV.(Courtesy: R.D. Murphy/10th Mountain Division)

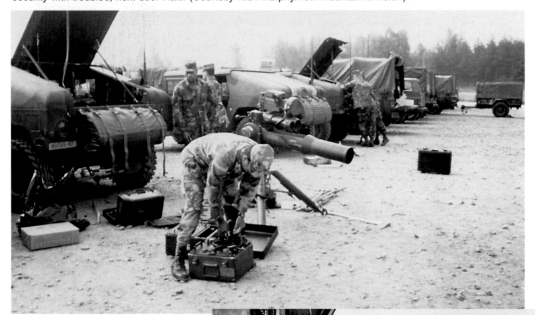

Soldier airmen from the 25th Assault Helicopter Regiment, 10th Mountain Division (Light Infantry), load a UH-1H Iroquois helicopter aboard an Air Force C-130 Hercules aircraft at Wheeler-Sack Army Airfield. Usually ground handling wheels are added to skid helicopters to facilitate aircraft loading/unloading. Note the folded troop seats on the aircraft fuselage sides. The 10th Mountain Division is one of the most rapidly deployable fighting forces in the U.S. Army's Order of Battle. (U.S. ARMY)

Members of the division's support and logistics unit prepare a cargo shipment of ammunition and supplies that are going to be sling-loaded underneath a Blackhawk helicopter to a 105mm howitzer gun battery with the division training in the woods of upstate New York. (Courtesy: R.D. Murphy/10th Mountain Division)

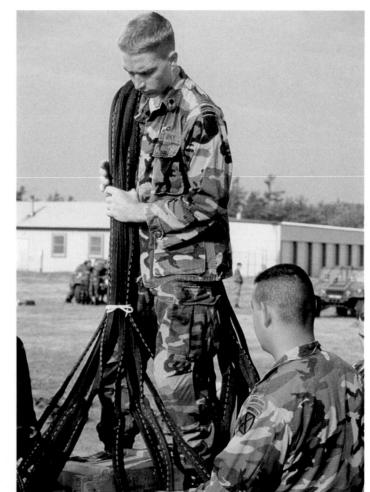

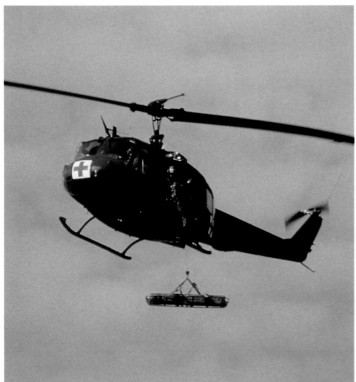

A Bell-212 (UH-1H) Medevac from the 10th Mountain Medical Battalion ferries a wounded trooper in an airborne-rigged "Stokes" litter to a hospital at Fort Drum. A combination sled/cart as used by the Austrian Army called the UT 2000 could also be used as a Stokes-litter for MEDEVAC in areas where helicopters cannot land due to lack of space, obstacles and/or rotor wash strewn loose snow "white-out" which can blind pilots. The Bell-212s are being phased out of service in the 10th Division, although not yet in reserve formations still operating with the division, such as its own reserve brigade (the 27th New York) in favor of the UH-60. Surplus UH-1Hs will be provided to allied countries defending themselves from internal/external aggression. (Courtesy: R.D. Murphy/10th Mountain Division)

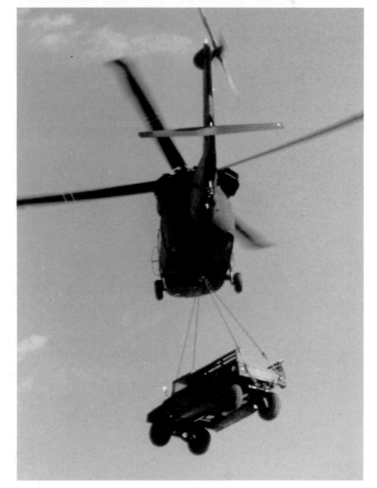

Providing itself as the U.S. Army's mainstay transport and utility helicopter—for the next generation of whirlybird wonders—a UH-60 Blackhawk from the 3rd Battalion, 25th Aviation Regiment provides "parcel post" service with a "Humvee" to an awaiting infantry force. The Blackhawk's lift capacity of 8,000 pounds is just enough to lift a loaded 6,000+ pound HMMWV. (Courtesy: R.D. Murphy/10th Mountain Division)

This photograph of 14th Infantry Regiment personnel preparing to board a 25th Aviation Regiment UH-60 Blackhawk offers an excellent view of the MILES equipment worn by these 10th Division troopers. The box at the harness rear holds the microprocessor that determines if "enemy" coded laser beams are a killing hit or a wounding impact. MILES allows force-on-force war games so soldiers can experience fighting a living adversary, not just a scripted simulated opponent that always does what is expected. (Courtesy: R.D. Murphy/10th Mountain Division)

A group portrait of 14th Infantry Regiment personnel as they assembled in front of their UH-60 Blackhawk as the section commander issues their orders in an impromptu landing strip briefing; the force is being heli-lifted several kilometers away to outflank members of the 22nd Infantry Regiment during exercises. Note mortarman, equipped with the 60mm M224 lightweight mortar. Vertical envelopment tactics were pioneered by the U.S. Army after W.W.II, culminating with air-mobile operations in Vietnam. Today all Army divisions have an air-mobile component. (Courtesy: R.D. Murphy/10th Mountain Division)

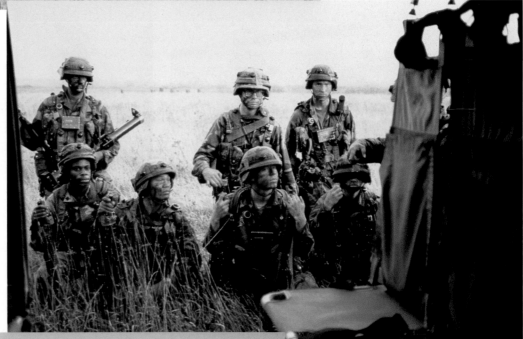

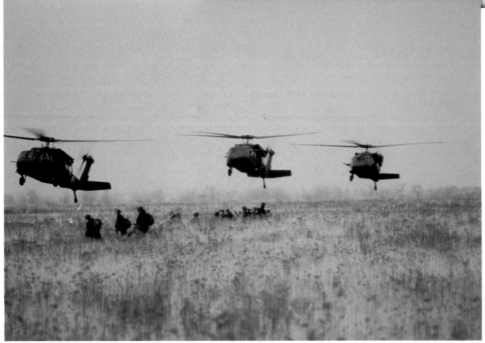

The cavalry has arrived...the 17th Air Cavalry, that is. Impressive photograph of three UH-60 Sikorsky Blackhawks landing at an open field to pick up their charges. Air-landing helicopters into large, open danger areas is a combat liability learned from Vietnam combat. Army planners are trying to get away from this predictable technique by using rappelling and better yet, Fast Rope Insertion/Extraction (FRIES) systems to insert troops into landing points in closed terrain. All conventional U.S. infantry forces would be wise to adopt, an enduring lesson from Vietnam war battles like Ap Bac. 10th Mountain Division soldiers acting as the mobile, quick reaction force for the Rangers during the October 3d leadership raid in Somalia were not trained to fast rope to come to the aid of the Rangers; they had to come in by soft-skin, unarmored ground vehicles that were ambushed and blocked along the way. All it takes to get basic fast rope confidence/skills is a sturdy high tree or structure with a standing platform under a hung fast rope for soldiers to reach out and slide down. (Courtesy: R.D. Murphy/10th Mountain Division)

Interesting photograph of a 17th Air Cavalry UH-60 (with hatch mounted spade-grip M60D 7.62mm machine gun) and its covering AH-1S Cobra, as they prepare to support troops in the field during exercises. Unfortunately the 10th Mountain's Quick Reaction Force (QRF) was not fast-rope qualified to rapidly reinforce the Rangers pinned down defending helicopter crash sites in Somalia during the October 3d leadership raid. Hopefully in the future, all division helicopters will be FRIES equipped. (Courtesy: R.D. Murphy/10th Mountain Division)

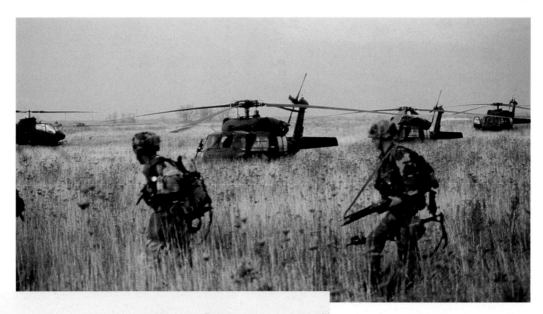

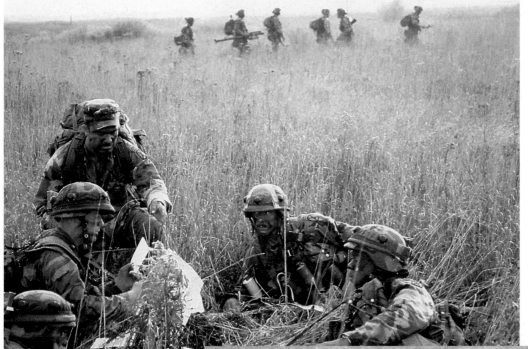

With the choppers long gone, this forward element of the 10th Mountain Division deploys in a defensive perimeter; awaiting the arrival of the remainder of the battalion. Note trooper, center, with a wide variety of M18 colored smoke grenades attached to his Individual Tactical Load Bearing Vest for Landing Zone (LZ) marking, tactical screening, and target marking. (Courtesy: R.D. Murphy/10th Mountain Division)

Teamwork and expedience. Soldiers of the "10th" are taught to act as a team, and reach their objectives as quickly and efficiently as possible. A classic example of the division's prided teamwork ethic is displayed here, in this field briefing prior to attacking a target during battalion level exercises. Note BDU pattern camouflaged combat assault pack from top of Field Pack Large Internal Frame (FPLIF) rucksacks, and trooper (right) equipped with an AN/PRC-126 squad radio or modern-day "walkie-talkie." (Courtesy: R.D. Murphy/10th Mountain Division)

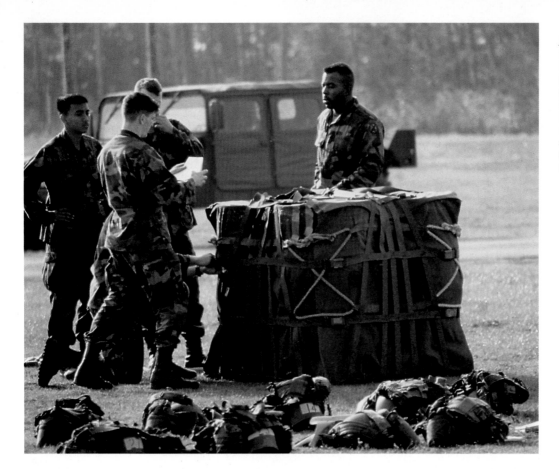

Prior to setting out for a training jump in the northern wooden country near the Canadian frontier, 10th Mountain Division logistics personnel prepare supplies and ammunition to be para-dropped by C-130 Hercules. Method usually used is mass Container Delivery System (CDS) off the rear ramp using the rail system, though a small 66" x 30" x 48" door bundle can be used. (Courtesy: R.D. Murphy/10th Mountain Division)

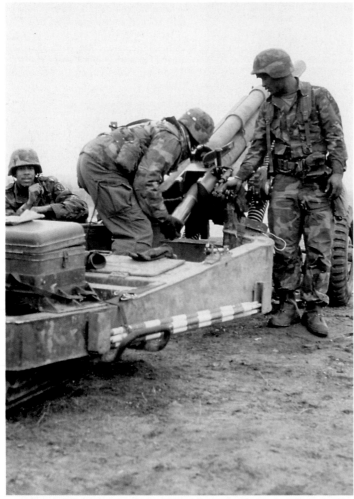

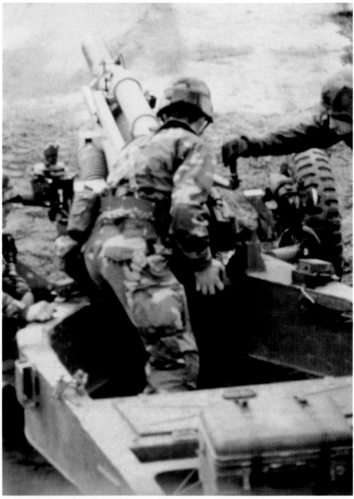

Gunners from the 7th Field Artillery Regiment fire their 105mm field howitzer. In proper deployment scenarios, the unit's artillery pieces are brought up to the "front lines" courtesy of the division's fleet of helicopters, then displaced by HMMWVs to alternate firing positions to avoid enemy counter-battery fire. External sling-loading is faster than internal loading in most heliborne "Air-mobile" scenarios. (Courtesy: R.D. Murphy/10th Mountain Division)

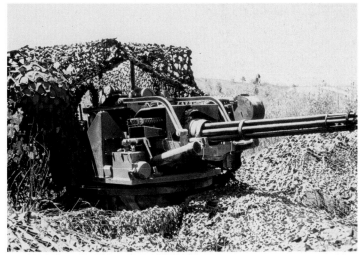

A well-concealed M167 Vulcan 20mm Gatling Gun anti-aircraft gun, belonging to the 62nd Air Defense Artillery Battalion is readied for target practice. The Vulcan is an extremely lethal air defense system, deployed by the division in its towed form. In Panama, it was used to put on convincing firepower displays that caused many PDF soldiers to surrender, saving lives and collateral damage. (Courtesy:R.D. Murphy/10th Mountain Division)

Wearing his ALICE web gear, as well as the division's subdued patch on his woodland pattern BDUs, a 62nd Air Defense Artillery Battalion Vulcan gunner places his target, an aging QF-102 drone, in the center of his sights. The M167A2 is easily airdropped, STOL air landed and/or towed by HMMWVs. Helmet camouflage band "cat eyes" are clearly visible. (Courtesy: R.D. Murphy/10th Mountain Division)

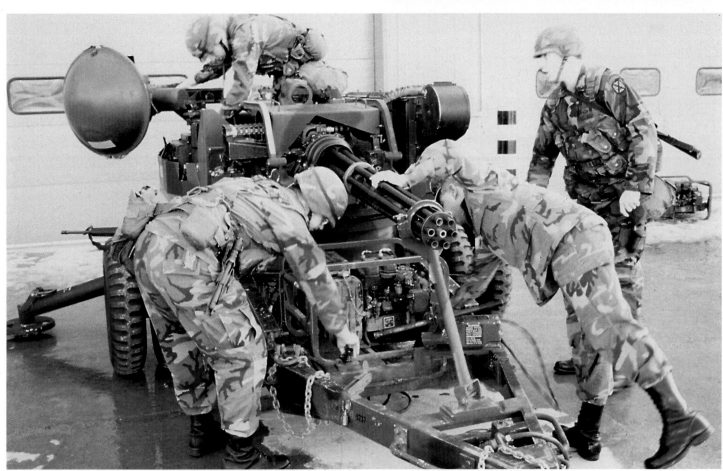

Excellent view of the towed M167 Vulcan 20mm Gatling Gun as its set-up for transport, trail legs joined for towing eye hook-up. The Vulcan's ability to spew out either 1,000 (ground role) rounds a minute or 3,000 (air defense role) rounds a minute make it one of the most devastating weapon in the division's arsenal. (Courtesy:R.D. Murphy/10th Mountain Division)

New World Order Deployments

Troop review; on arrival, many United Nations dignitaries inspected the 10th Mountain Division before assuming full-scale peacekeeping duties. (U.S. ARMY)

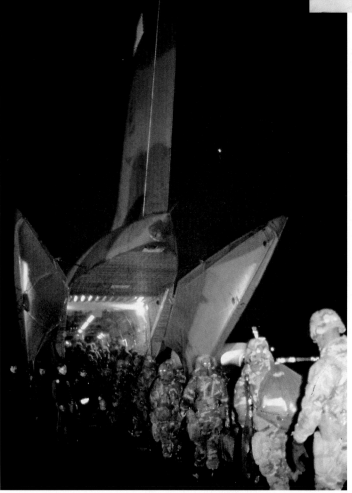

Just 463 C-141B sorties delivers the 10th Mountain Division to any place in the world, not taking part in Desert Shield/Storm, the Division was ready to meet the Somali crisis as part of the XVIII Airborne Contingency Corps based at Fort Bragg, North Carolina. (U.S. ARMY)

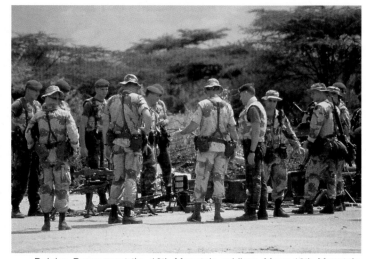

Belgian Paras meet the 10th Mountain soldiers. Many 10th Mountain soldiers are Airborne qualified, and with computer-assisted personnel selection the entire sub-units of the Division could be parachute deployment capable; not on monthly jump status, but capable for a parachute administrative deployment behind fellow XVIII Airborne Corps paratrooper units of the 82d Airborne Division into drop zones if landing strips are not available or tactically not worth the casualties to seize by direct parachute assault. This deployment option would have proved useful had Somalia not had a long runway built during the days of Soviet military assistance. The Belgian Paras are shown exchanging information to the Light Fighters on what to expect from the warlord gunmen and how to counter their weapons hiding tactics. (Courtesy: Belgian Defense Attaché)

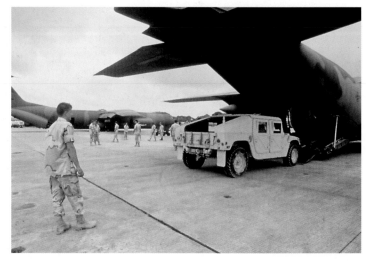

A 10th Mountain Division "Humvee", with its Somali-theater tan camouflage scheme seen here to advantage. The basic soft-top cargo variant is the M998 or hard-top M1044 model depicted here. A C-130 can STOL airland 3 HMMWVs. HMMWVs can be carried side-by-side in C-5B/C-17s. Division HMMWVs used in Somalia were later fitted with barbed wire and anti-handling barriers to prevent crowds thronging around the vehicles from tearing off extra support gear or reaching inside the vehicle for troop belongings. (U.S. ARMY)

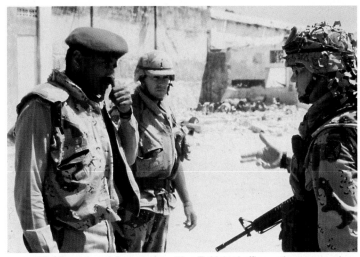

10th Mountain soldiers confer with a Pakistani officer, whose men when killed in an ambush by warlord Aidid's men triggered the U.N. mission to track down and capture the rebel warlord. (U.S. ARMY)

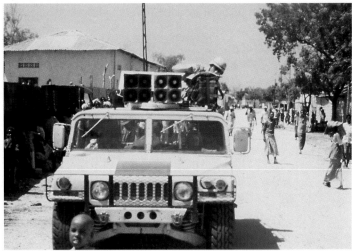

Since many Somalis cannot read or write, loudspeaker "Psyops" HMMWVs were used to offer appeals for cash/food rewards for turning in weapons/ammunition. When fear of the warlords was not over-riding the famine stricken people responded with good intelligence as to where arms were cached. (U.S. ARMY)

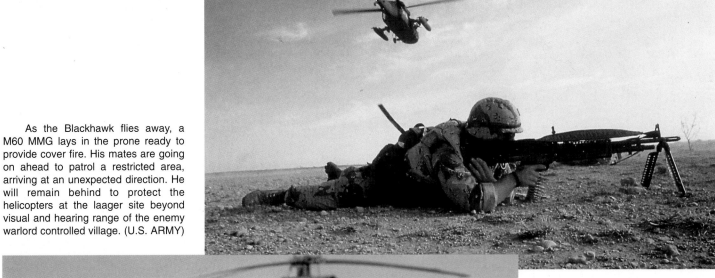

As the Blackhawk flies away, a M60 MMG lays in the prone ready to provide cover fire. His mates are going on ahead to patrol a restricted area, arriving at an unexpected direction. He will remain behind to protect the helicopters at the laager site beyond visual and hearing range of the enemy warlord controlled village. (U.S. ARMY)

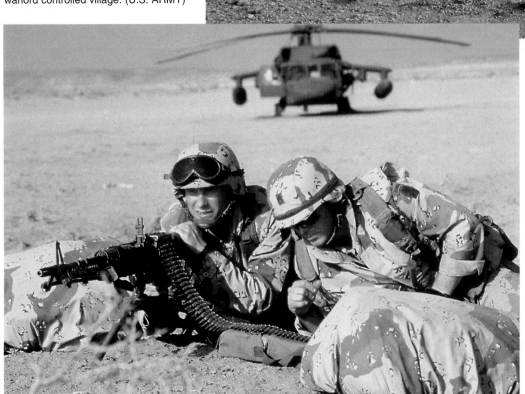

Meanwhile, back at the laager site the M60 Medium Machine Gun team covering the Blackhawk are resting but are growing anxious for the patrol to report in its findings. The goal is to leave the laager site before nightfall to return to the "safe" area at the guarded international airport. (U.S. ARMY)

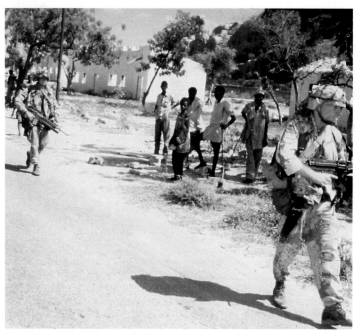

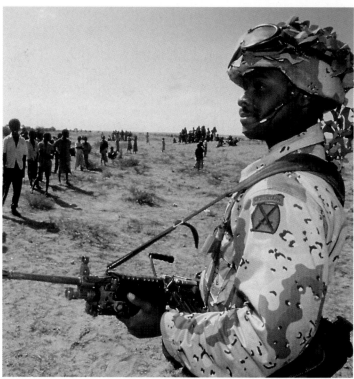

On patrol, 10th Mountain troopers attempt to make contact with a villager willing to talk about the location of Aidid or hidden weapons. Language-capable Special Forces soldiers were often detached to assist Light Fighters with communications in a strange tongue. (U.S. ARMY)

Suspicious villagers and those caught with weapons are moved to a nearby location for interview by an interpreter. Searching for gunmen hidden weapons is dangerous and time consuming; a M249 light machine gunner stands guard. He is wearing 6-color desert pattern BDUs or DPUs, a desert cover is over his PASGT flak jacket. (U.S. ARMY)

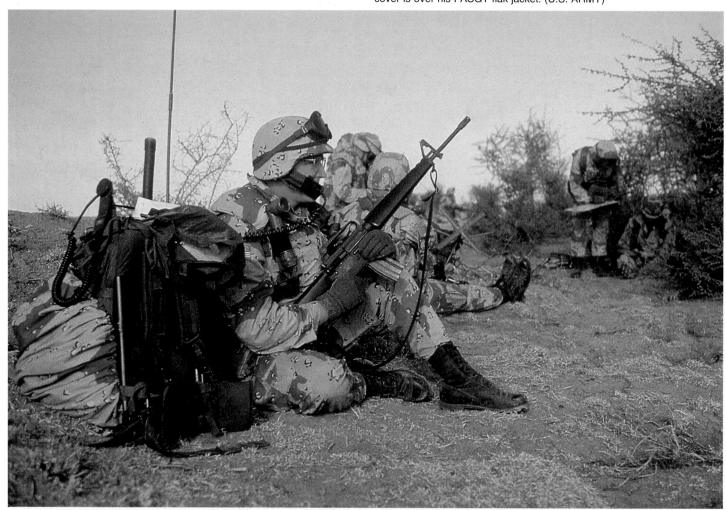

The security patrol finally radios in a checkpoint on the map; weapons have been found that needs to be picked up by a soft-skin vehicle on signal. The olive drab load bearing equipment's green color contrasts adversely to the desert camouflage efforts of the DPUs and flak jacket cover. A BROWN color for all web gear in U.S. military service would work better in all climates, to include the sun-baked dust of Somalia. (U.S. ARMY)

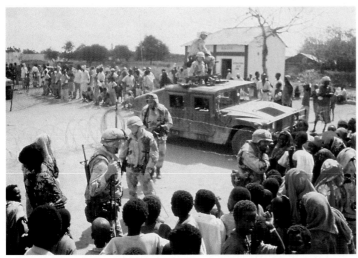

The downtown patrol stops in the city center awaiting word on the helicopter lift of food supplies inbound from the airport miles away. (U.S. Army)

A key relief element is clean, drinking water made from reverse-osmosis water purifiers or ROWPUs. A 10th Mountain trooper picks up a weapon from the truck bed with a water container at the rear. ROWPUs will need to purify from available stagnant water or even sea water large quantities for the peace-keepers and suffering civilians. (U.S. Army)

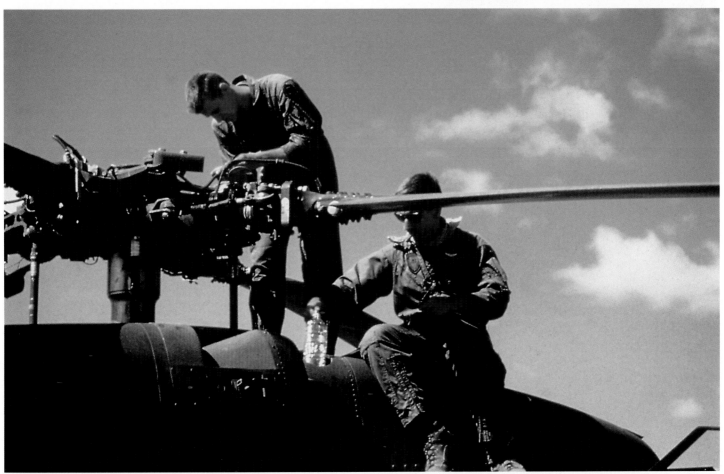

Helicopter maintenance continues back at the laager site in the Somali dust. Dust was a perplexing problem for helicopters and ground vehicles alike in Somalia. (U.S. Army)

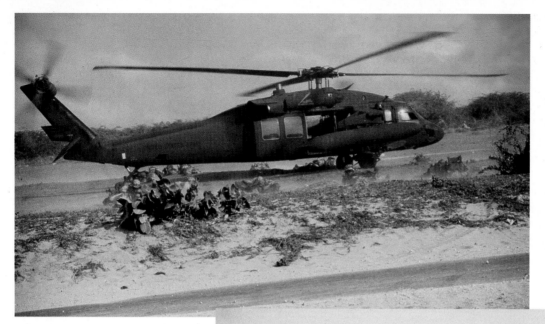

To meet mission demands of long distances to be traveled and loiter time for fire support on the battlefield Blackhawks are fitted with ESSS stations for extra fuel, rockets and missiles. Once a fire-fight begins below for the transported infantry, the Blackhawks must be flying a short distance nearby to pick them up for repositioning the men behind the enemy's flank or rear or to pour in suppressive fires from above. Blackhawk ESS in trail formation; a beautiful sight for the defenders of freedom, but a terror to Somali gunmen; upon landing a powerful 10th Mountain Division infantry force will be maneuvering on them looking to locate their hidden arms caches accumulated from years of former Soviet Union supplied cheap weaponry. (U.S. ARMY)

Troops with rucksacks desert covers assemble by the UH-60 for the flight back to the U.S. forces base. The mission as success, they will have many "war stories" to tell over a "cold one" back at the G.I. tent city. That no casualties were taken owes a lot to the unexpected nature of their visit and a good deal of divine providence. U.S. forces routinely deploy with chaplains to meet spiritual needs of soldiers and to keep the focus on the moral importance of their mission and service. (U.S. ARMY)

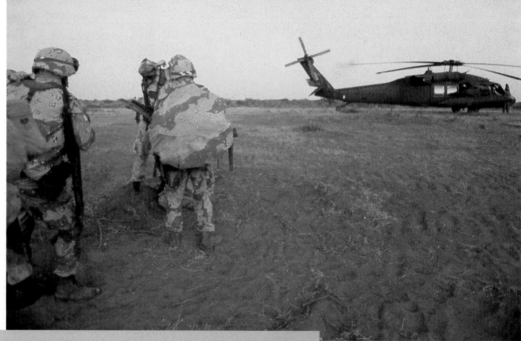

The Light Fighters examine the captured Somali weapons seized during the get-away attempt and from the reported cache. The weapons were trucked back by a M939-series 5-ton truck. A doorless M1038 HMMWV soft-top cargo carrier is at the rear. A roll bar with turret available from AM General can be added to soft-top HMMWVs so they can be mounted with .30 caliber Medium, .50 caliber or 40mm Heavy Machine Gun stands to act as a high rate of fire weapon to counter enemy ambushes. Light Fighters improvised by laying machine gun bipod legs on top of the HMMWV front section's canvass roof for a ready fire response. Firmer mounting insures readiness and improves fire stability. (via Joel Paskauskas II)

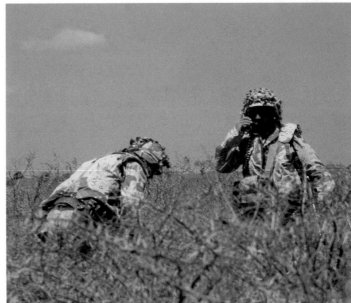

On patrol in the sun-baked bush near Baidoa, a 10th Mountain Division radioman calls in for a navigation check prior to proceeding with a patrol of a nearby supply route. (via Joel Paskauskas II)

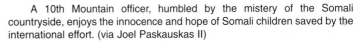

A 10th Mountain officer, humbled by the mistery of the Somali countryside, enjoys the innocence and hope of Somali children saved by the international effort. (via Joel Paskauskas II)

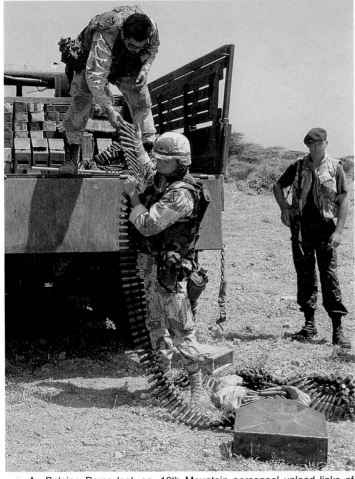

As Belgian Paras look on, 10th Mountain personnel unload links of ammo for their forward fire position en route to Baidoa. (via Joel Paskauskas II)

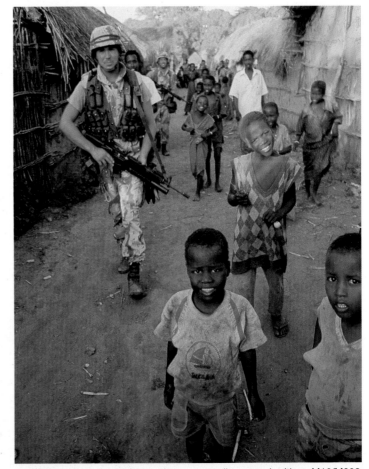

Affected by the heat squalor, a grenadier armed with a M16/M203 walks through a Somali village on patrol. Obviously, the presence of the 10th Mountain Division made the reliefs distribution a reality. (via Joel Paskauskas II)

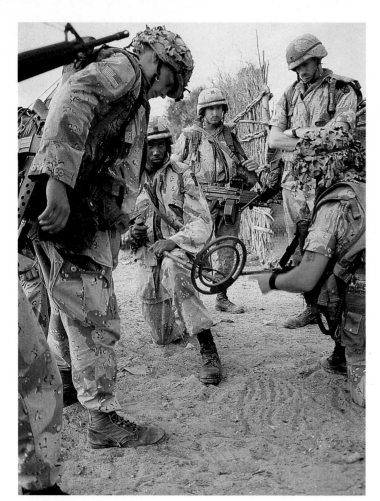

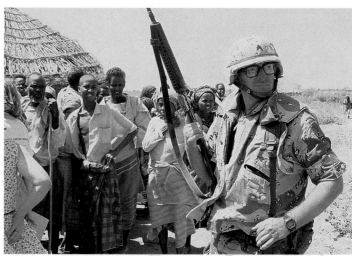

A 10th Mountain trooper stands at the ready at a relief center near Baidoa, one eye on the food supply and one finger on the trigger of his M16A2 5.56mm assault rifle just in case any armed bad guys attemps to help themselves to the internationally donated supplies. (via Joel Paskauskas II)

Careful where you step! Not too anxious to lose a limb or one's life, troopers take seriously the reports of a minefield and call in a sweeper to detect and isolate the possible devices. Note squad gunner carrying M249 SAW. (via Joel Paskauskas II)

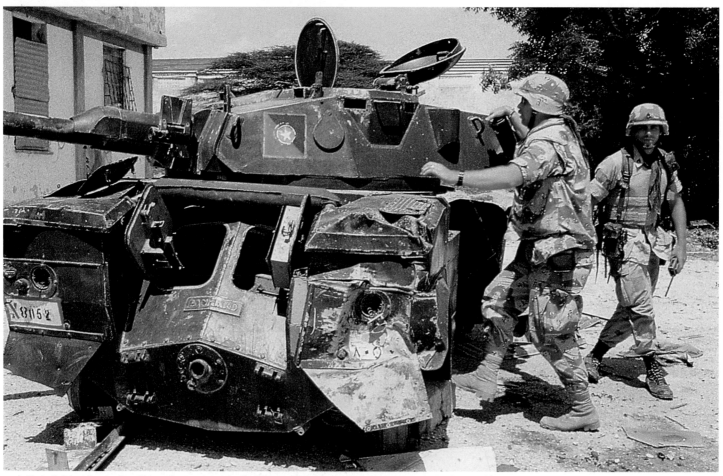

Two divisional security officers (note protective bullet-proof vests) examine the remains of a former Somali regular army Panhard AML H90 armored car. (via Joel Paskauskas II)

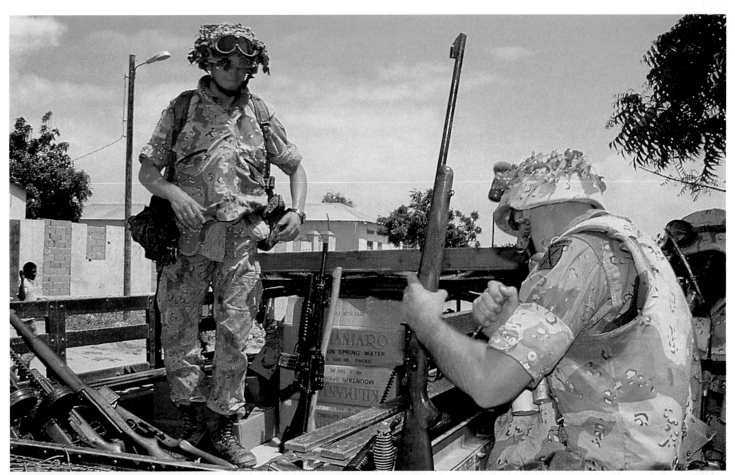

Gunsmithing 101 - courtesy of the 10th Mountain Division (Light Infantry). Two light troopers examine a haul of weapons seized by a patrol near Baidoa and attempt to check the antiquated foreign mix for rounds discarded in chambers or worse, booby trapped barrels. (via Joel Paskauskas II)

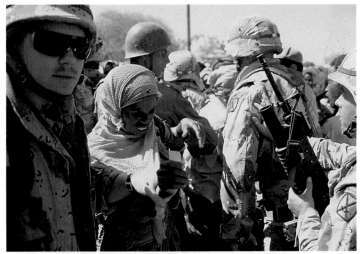

Light troopers and Moroccan infantrymen attempt to keep order in a food distribution center. The 10th Mountain Division (Light Infantry) contingent to "Restore Hope" and UNOSOM II were fortunate to encounter only minimal resistance. (via Joel Paskauskas II)

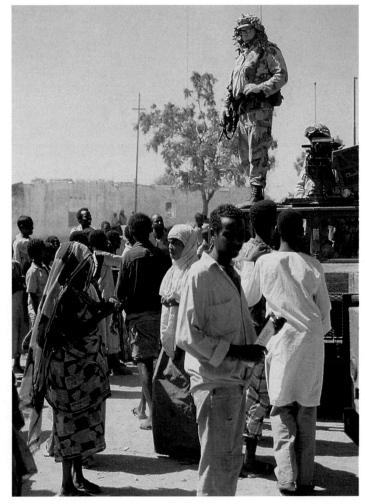

A light trooper grenadier, wearing a PASGT crammed with additional rounds of ammunition and grenades, stands guard over a food distribution center atop a HUMVEE as a comrade stands guard with his fingers on the trigger of a Mk. 19 40mm grenade launcher. (via Joel Paskauskas II)

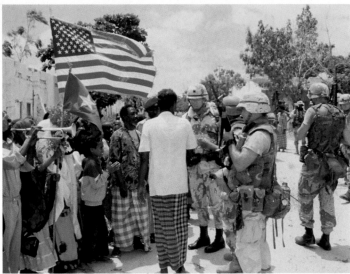

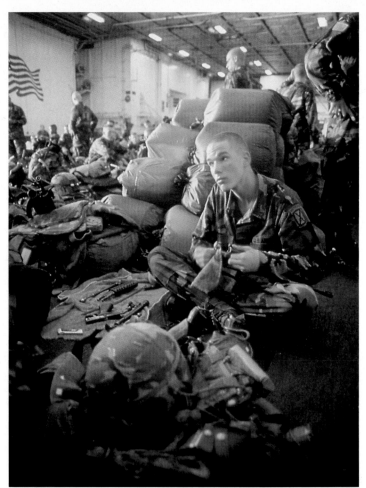

U.S. thank-you rally; despite media reports the majority of the starving Somali people were glad U.S. forces came to feed them and protect them from warlord gunmen. That gunmen can use U.S. casualties to make these efforts dwindle means that U.S. military forces must "burn the midnight oil" to develop absolute battlefield superiority to prevent ANY casualties from happening. Much could be done if the attempt were made and the easy excuse that "casualties are inevitable in a contested peacekeeping operation that gives way to peacemaking" avoided. The 10th Mountain Division did well in Somalia but must lead the way towards a better approach since it will be light forces leading the way in future contingency operations. Throughout this book we have alluded to these kinds of low-cost improvements; Extreme Terrain Bicycles, carts, gun shields, vehicle armoring, recoilless rifle shock weapons on HMMWVs, training Mountain Division soldiers to fast rope etc. Certainly the Division should be rewarded for its Somali service with a unique brown beret or since it is a part of the XVIII Airborne Corps, a maroon beret. With computer assisted personnel placement, the Division could be filled with Airborne qualified soldiers, making the latter suggestion acceptable. (via Joel Paskauskas II)

Mountain soldiers clean their weapons during the long hours of "hurry up and wait" on board the U.S.S. Eisenhower en route to Haiti. (U.S. ARMY)

10th Aviation Brigade, 10th Mountain Division Cobra and OH-58 Kiowa sit atop the flight deck on the U.S.S. Eisenhower prior to heading toward the Haitian coast and the commencement of "Operation Uphold Democracy." (U.S. ARMY)